IN THE EYES OF OUR CHILDREN

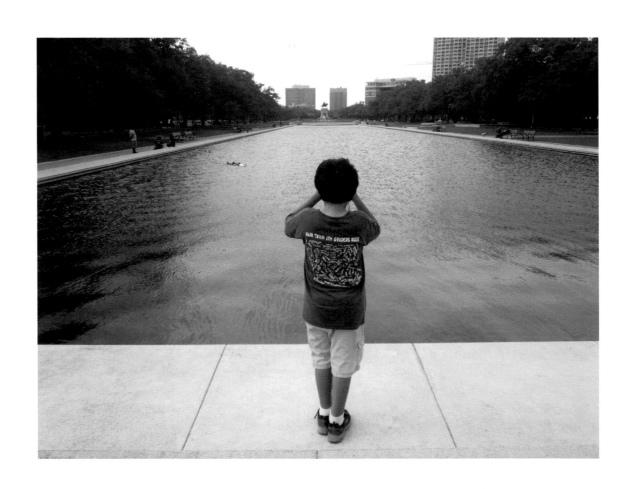

Raffaele Cardone photographing in Hermann Park

Preface

This book and the accompanying exhibition offer a unique vision of the city of Houston. The city is seen, at this moment in its history, through the eyes of its children.

With instruction and guidance, 132 elementary and middle school students — age 6 to 16, of diverse racial and cultural backgrounds—worked in still photography and printmaking to create this vision of their home and place in the world. In their exploration of the city as well as their photography, I served as their principle guide and the editor of their work. My wife, the artist Janice Freeman, guided the children in their printmaking. The project unfolded over six years, and at all times we viewed our work with the children as a collaboration more than a teaching challenge. We observed, made suggestions, and marveled at their innate skills. Undergraduate student volunteers from Rice University joined in our collaborative efforts, taking leadership roles at the participating schools and in our summer workshops.

If the quality of the children's photography and printmaking is striking, that should not be surprising. The truth is that children do not need to be taught how to photograph any more than they need to be taught how to play. The equivalent is true, I believe, in the traditional studio arts. Observation, discovery, and artistic invention come naturally to children.

What we sense in these photographs and prints is the archetypal innocence, curiosity, and authenticity of the child. There is a total lack of ego, artistic posturing, or striving for "self expression." Instead, the city, in all its rich diversity, is pictured here with a sense of wonder. The city, in fact, appears to be the real artist—an artist of unrivaled originality and inventiveness—as it calls us simply to look and contemplate its best works.

Geoff Winningham, *Editor*

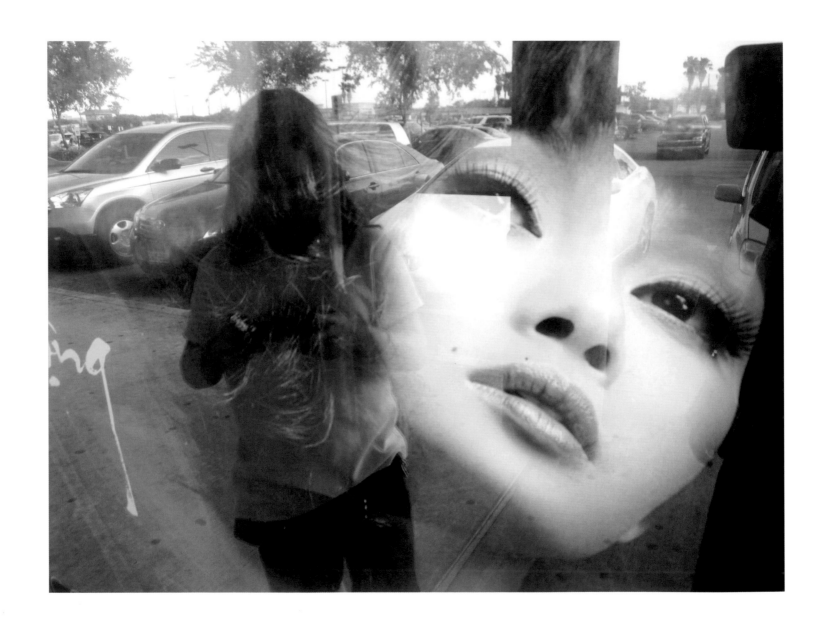

PHOTOGRAPH BY RACHAEL LEE
Third Grade, Mark Twain Elementary School

Nina Ignatiev Photographing at the Hong Kong Mall

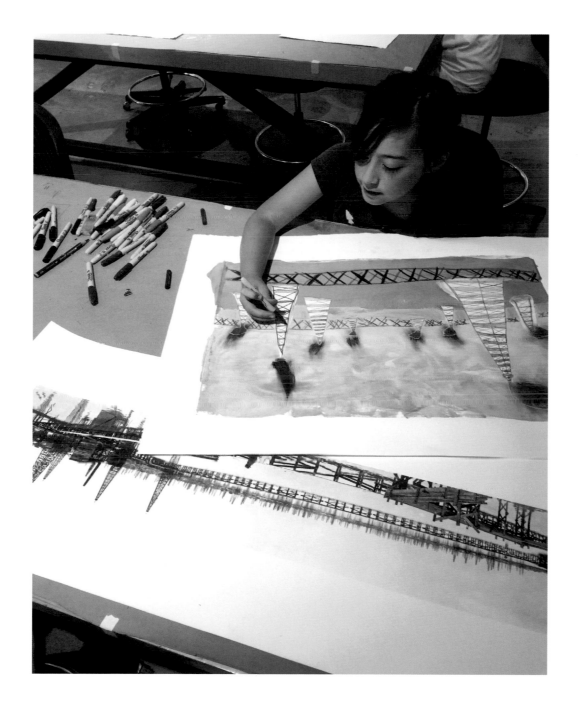

STARLA SÁNCHEZ WORKING ON A MONOPRINT

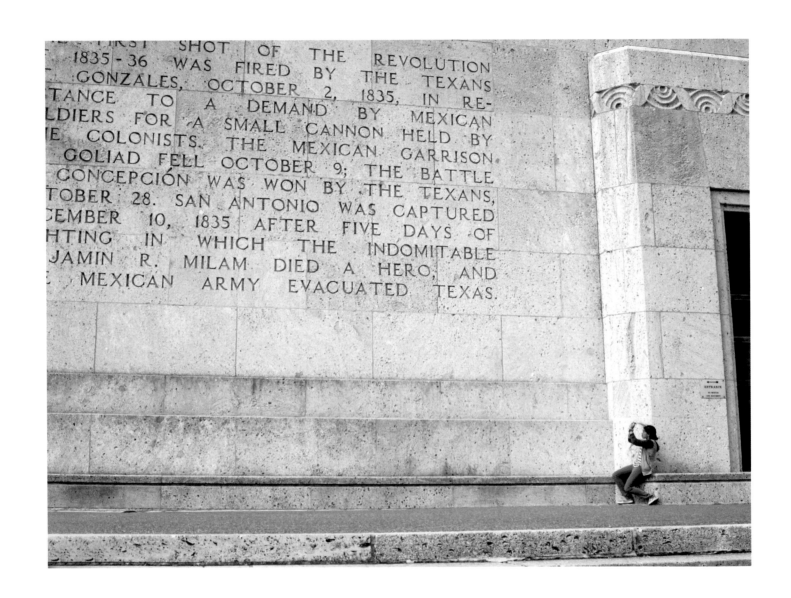

IMNET PETRO PHOTOGRAPHING AT THE SAN JACINTO MONUMENT

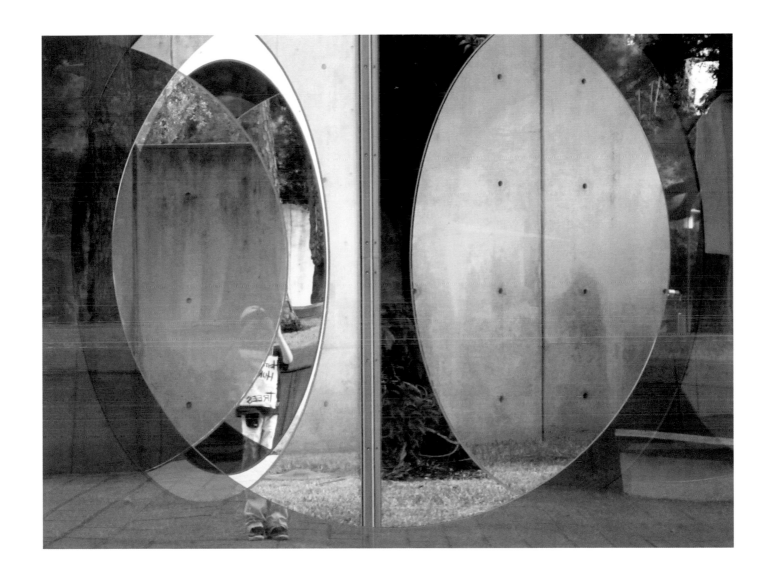

PHOTOGRAPH BY RICHARD VILLALOBOS
Third Grade, Love Elementary School

In the Cullen Sculpture Garden of the Museum of Fine Arts, Houston

WORKSHOP SESSION IN THE RICE UNIVERSITY PRINTMAKING STUDIO

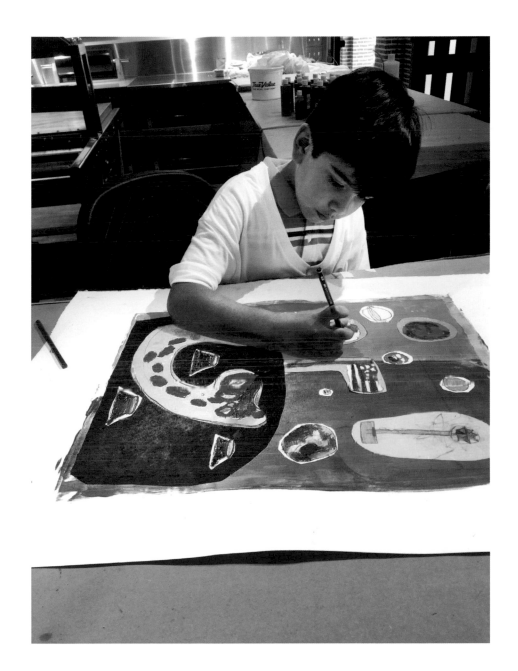

ANGEL CORPUS WORKING ON A MONOPRINT

Gracie Burns photographing in the Japanese Garden

Citlali Arzola photographing in the Canino Airline Market

Silvia Méndez, Rebecca Wolfarth, Elle Devine, and Gabriela Rodríguez
WORKING ON MONOPRINTS
(left to right, above)

Mauricio Rivera photographing in the Canino Airline Market

Love Elementart School students photographing an art car on 19th Street

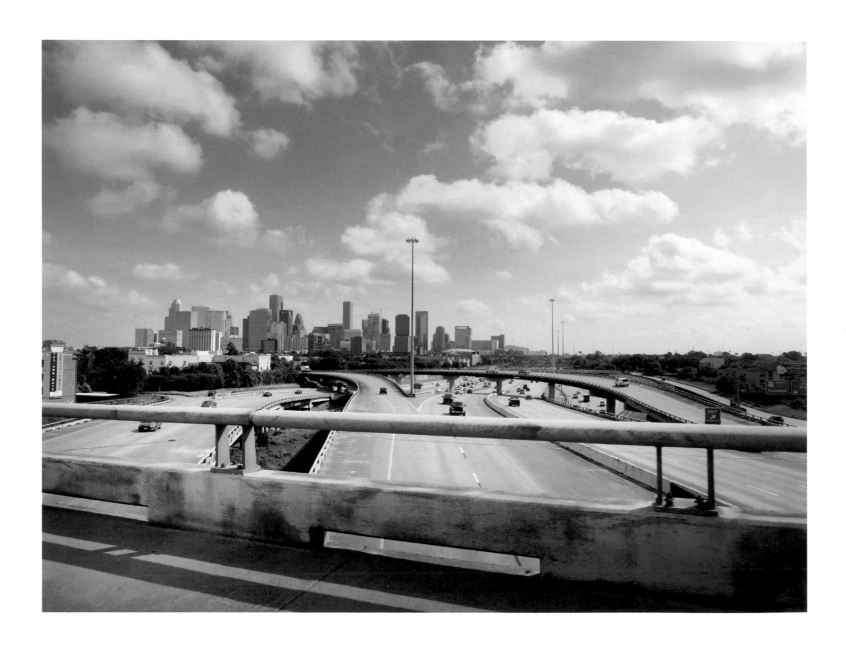

PHOTOGRAPH BY ABIGAIL OYERVIDEZ
Fifth Grade, Wilson Montessori School

Houston Skyline Seen from Highway 59 Overpass

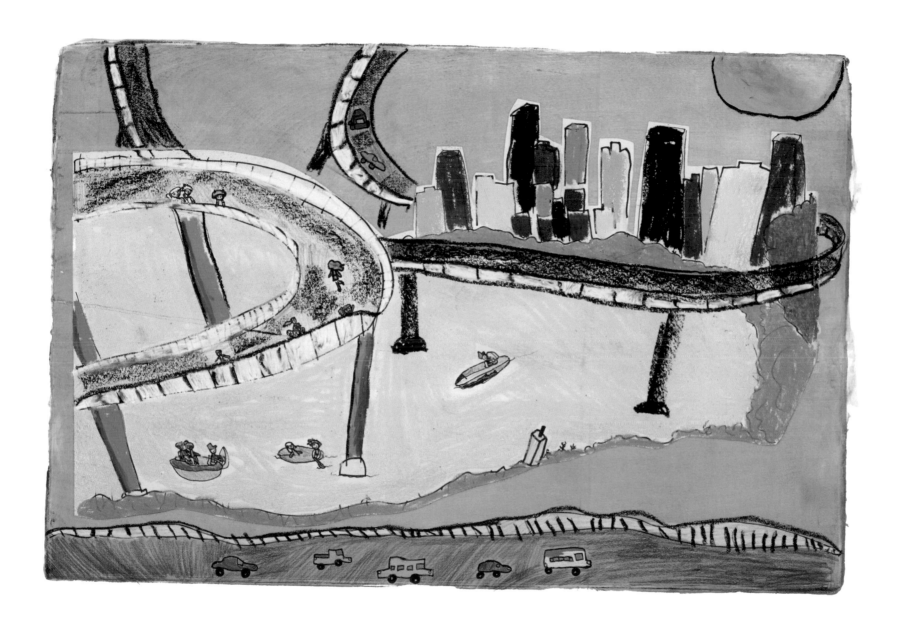

Monoprint with color pencil, markers, and pastel
by Starla Sánchez
Fourth Grade, Mark Twain Elementary School

Houston Today

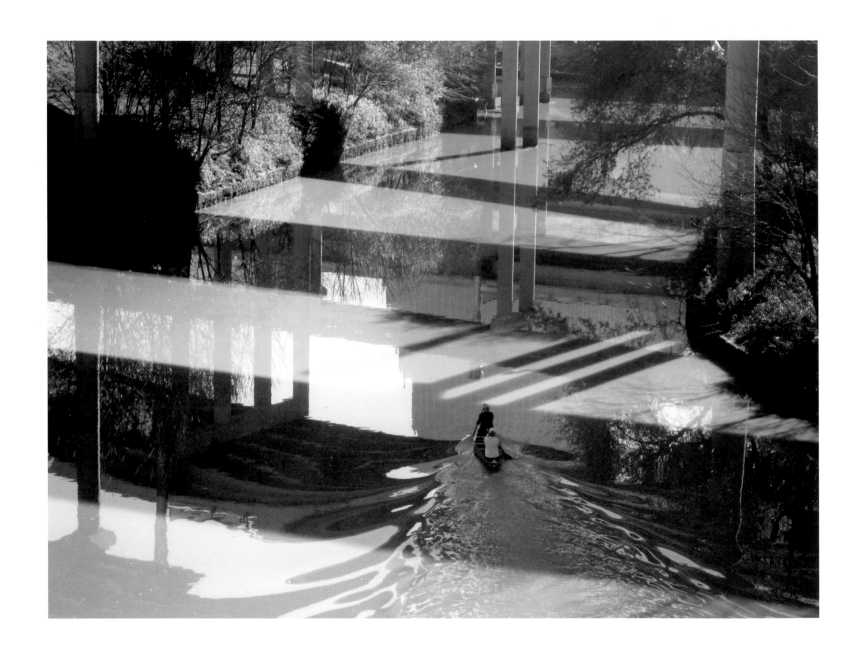

PHOTOGRAPH BY ANGEL MENA
Fifth Grade, Love Elementary School

Canoeing on Buffalo Bayou under Interstate 45

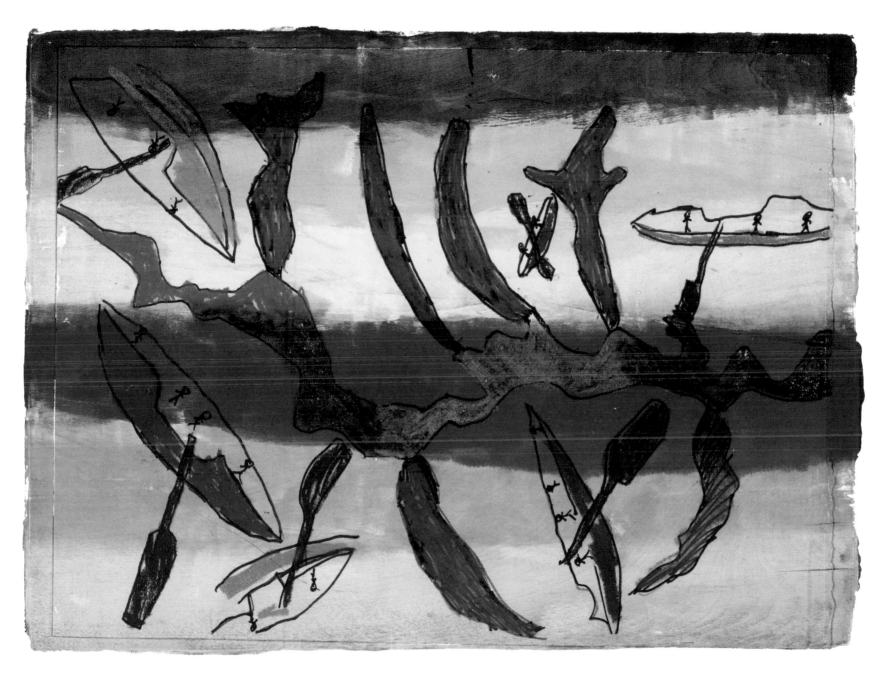

Monoprint with color pencil, markers, and pastel
by Dominick Reyes
First Grade, Love Elementary School

Buffalo Bayou and Its Tributaries

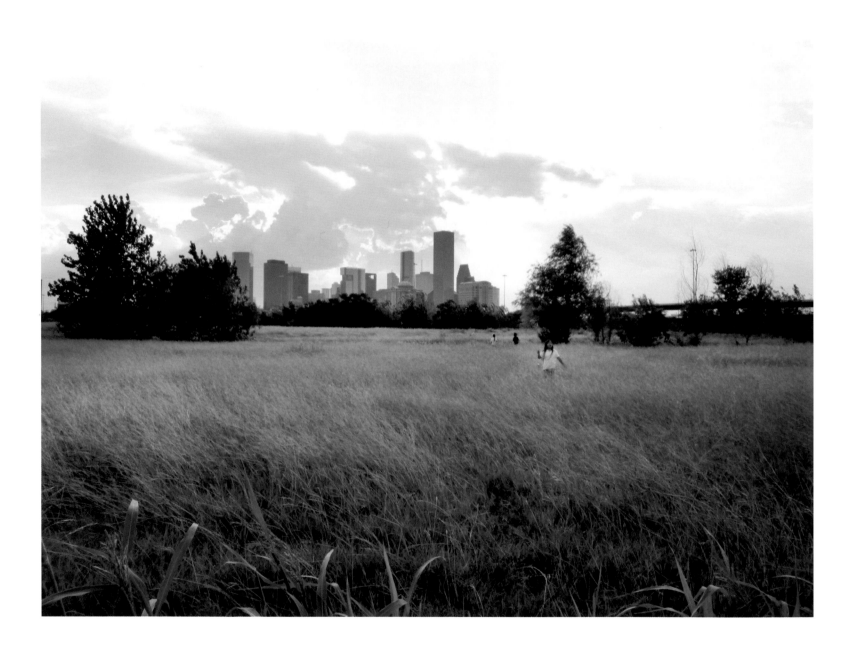

PHOTOGRAPH BY GABRIELA RODRÍGUEZ
Kindergarten, Treasure Forest Elementary School

Love Elementary School Students Photographing in the Third Ward

In the Eyes of Our Children

HOUSTON, AN AMERICAN CITY

Photographs and Prints by Houston Schoolchildren, 2011–2016

POZOS ART PROJECT

HOUSTON

2017

The publication of this book was made possible
by major financial support from:

Blank Rome, LLP

Barry and Sue Abrams

Robert Scott and Susan Bickley

The JBD Foundation

The Genesis Foundation

The accompanying exhibition, summer workshops, and the digital archive of the
project were made possible by financial support from:

Rice University
Department of Visual and Dramatic Arts
The Doerr Institute for New Leaders
Humanities Research Council

F.E.E.D. TX — Liberty Kitchen

Houston Arts Alliance

Houston First Corporation

Pattie Jard

First edition, 2017

ISBN# 978-1-5323-1731-6

Book Design by David Timmons
and Geoff Winningham

Printed in China

Contents

Project Staff and Volunteers

Project Director, Photography Coordinator & Book Editor
Geoff Winningham

Studio Art Coordinator
Janice Freeman

Assistant Project Director & Consultant
Elizabeth Jordan

Assistant Studio Art Coordinator
Emily Whittemore

Administrative Assistant
Araceli Enríquez

Rice University Volunteer Teaching Assistants
Dorin Azerad
Marielle Brisbois
Claudia Casbarian
Julia Casbarian
Erica Cheung
Ben Davis
Helene de Mello
Sophia Erhard
Abbigail Gutiérrez
Lara Hansmann
Frankie Huang
Denise Iusco
McKenzie Johnson
Hallie Jordan
Estéfani Pérez
Isaac Phillips
Gloria Quintanilla
Kaitlin Smith
Jaylon Wesley
Linda Wu
Wendy Wu

Participating Schools and Students

Hamilton Middle School

Rice University Student Volunteer:
Dorin Azerad

Participating Teacher: Patti Hernandez

Participating Students:
Citlali Arzola
Eileen Bonilla
Valeria Cabrera
Angelina Cervantes
Alyssa Espinosa
Erik Guerrero
Guadalupe Medina
Miracle Renfro
Kelly Rivera
Jezel Valdéz
Caitlin Villareal

Sidney Lanier Middle School

Rice University Student Volunteers:
Denise Iusco
Gloria Quintanilla
Kaitlin Smith

Participating Teacher: Mike Kirby

Participating Students:
Alisson Aguirre
Dillon Allen
Anna Bremauntz
Alanis Castaño
Galdino Escalante
Corynn Ferrell
Caleb Harrera
Ian Heyman
Angus McCarthy
Catalina Parra
Martha Pirtle

Justin Rains
Ixtel Ramírez
Alexandra Rodríguez

Wilson Montessori School

Rice University Student Volunteer:
Marielle Brisbois

Participating Teacher: Constance Lewis

Participating Students:
Alek Blair
Elias Blair
Harper Gilbert
Reilley Jones
Alicia Meléndez
Abigail Oyervidez
Rhiannon Wolfarth
Rebecca Wolfarth

Kipp Zenith Academy

Rice University Student Volunteers:
Marielle Brisbois
McKenzie Johnson

Participating Teacher: Tanya Prejean

Participating Students:
Michael Broussard
Janice Brown
Mina Brown
Sierra Chavis
Daniela Díaz
Jordyn Griffin
Alena Lavallais
Janya Mackey
Destiny Miller
Melissa Rivas
Kai Tubbs

Participating Schools and Students

Las Americas Newcomers Middle School

Rice University Student Volunteers:
Dorin Azerad
Hallie Jordan

Participating Students, with Country of Origin:

Joti Bhujel, Ethiopia
Rodolfo Cerda, México
Narayan Chapagai, Nepal
Helen García, Guatemala
Nyashimwe Gashangu, Congo
Johara Jibril, Ethiopia
Huda Mashaan, Iraq
Tilisi Mlondani, Tanzania
Yoo Too Nie, Burma
Imnet Petro, Ethiopia
Ricardo Ramírez, El Salvador
Bader Rustom, Iraq
Beena Sanyasi, Nepal
Alisa Silwal, Nepal
Robel Tesfamichael, Ethiopia
María Torres, México

Love Elementary School

Rice University Student Volunteers:
Helene de Mello
Hallie Jordan
Kaitlin Smith

Participating Teacher:
Elizabeth Jordan

Participating Students:
Elena Alcalá

Citlali Arzola
Darío Avila
Lexi Baldwin
Akira Bonsen
Tristyn Bonsen
María Booth
Dylan Cassillo-Brown
Stella Cassillo-Brown
Francisco Cázares
Angel Corpus
Jaylen Davis
Elle Devine
Nate Devine
Edgar De Jesús
Heinrich Duarte
Estephania Espinoza
Adalia García
Yojan Hernández
Delylah Jiménez
Gabriela Kominek
Greta Lauder
María Martínez
Silvia Méndez
Angel Mena
Estéfani Mendoza
Joel Montealvo
Victoria Ortega
Luis Padilla
Thiraphat (Oat) Phenphichai
Alondra Reyes
Dominick Reyes
Kelly Rivera
Mauricio Rivera
Martha Sandoval
Alejandro Santillán
Kennedy Servín
Holland Van den Nieuwenhof
Lysander (Xander) Van den Nieuwenhof
Alyssa Vásquez
Sophia Vu

Damien Villarreal
Richard Villalobos
Terrance (T.J.) Washington
Zachariah Wrobel

Mark Twain Elementary School

Rice University Student Volunteers:
Sophia Erhard
Abbigail Gutiérrez
Frankie Huang
Denise Iusco
Estéfani Pérez
Isaac Phillips
Linda Wu

Participating Teacher:
Kathleen Blakeslee

Participating Students:
Caroline Anthony
Gracie Burns
Kyoto Berhane-Neff
Mathilda Black
Katie Byrd
Raffaele Cardone
Caeden Holly
Nina Ignatiev
Patrick Kelly
Makenna Lee
Rachael Lee
Callie Nichols
Sierra Ondo
Starla Sánchez
Nayak Shah
Grant Stidman
Georgie Rawson
Mary Rose Rawson
Ben Willcockson

Spring Branch Family Development Center

Rice University Student Volunteer:
Hallie Jordan

Participating children:
Jonathan Arellano
Kal-el Haggerty
Alexis Hill
Sheyla Ortíz
Kassandra Rodríguez
Jaden Washington

Additional Participanting Students

Crockett Middle School
Elle Devine
Lanier Middle School
Estephania Espinoza
The Rusk School
Annalise Rosenbaum
Pershing Middle School
Scout Sustala
Treasure Forest Elementary School
Gabriela Rodríguez

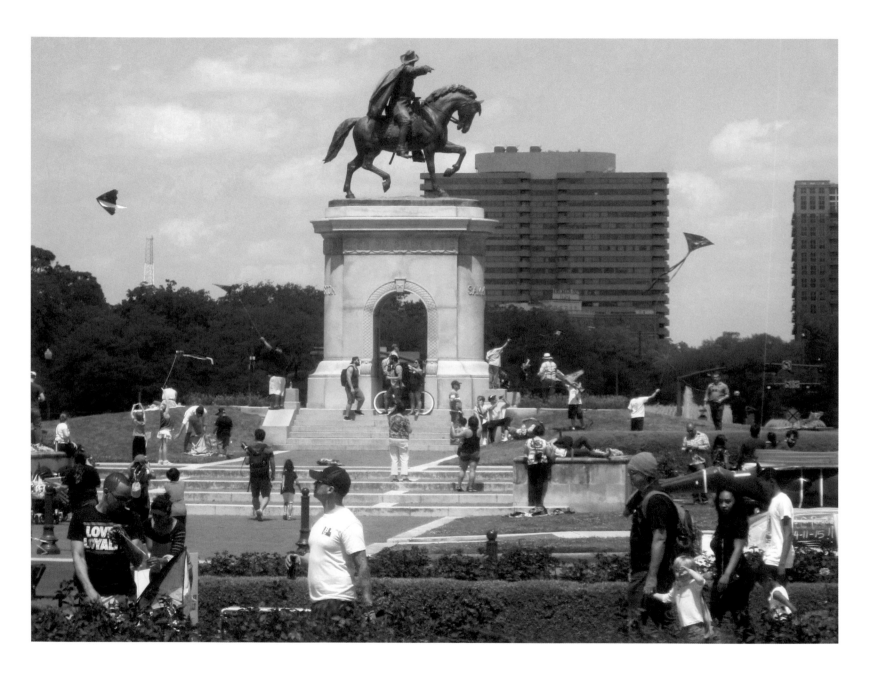

PHOTOGRAPH BY HOLLAND VAN DEN NIEUWENHOF
Third Grade, Love Elementary School

Kite Day at the Sam Houston Monument

FOREWORD

Is there any better way to see the world than through the eyes of a child?

As mayor of Houston, I have the unique privilege of serving the fourth-largest and most diverse city in our nation. Our city is full of young people from many different cultural and socioeconomic backgrounds. They hold the promise of our future, and how we inspire and empower them is up to us.

Faculty and students at Rice University, working with teachers in Houston area schools, have tapped into the creativity of our city's young people in a way I have not seen before. Through instruction in photography and printmaking, they have given these students a new lens through which to see the world around them. This is their uniquely created vision of Houston. It's a Houston rich with life and color, a place all of us should be proud to call our home.

I was born and raised in Houston's Acres Homes, where I continue to reside today. As a child, I remember my neighborhood's rural agrarian feel and the small one-story wood frame houses. I vividly recall the bus drive to downtown Houston with its futuristic skyscrapers. I dreamed that one day I would be in one of those tall buildings making a real difference. A bus trip to the other side of town transformed my perspective and future.

What we see matters, and the images contained herein capture the spirit of today's youth and how Houston continues to challenge and inspire. In the 180 years since its founding, Houston has defied the odds, rising from a swampy bayou to a futuristic global city. What is in store for the next 180 years? This is up to the children who contributed to this book, and I am deeply inspired by their work.

Sylvester Turner, *Mayor*
City of Houston

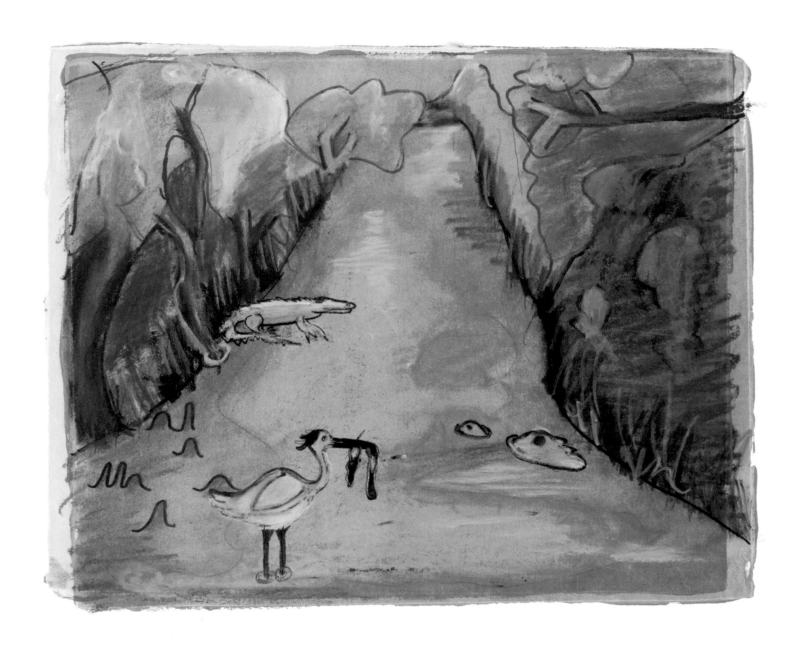

Monoprint with color pencil, markers, and pastel
by Rebecca Wolfarth
Fourth Grade, Mark Twain Elementary School

Buffalo Bayou, Long Ago

Part 1: The Primal Place and the Origins of the City

Long before the city existed—before the towering skyscrapers and monumental freeways, before millions of people made the city their home—there was the place, the primal place, as nature had shaped it over eons of time.

Millions of years ago, an ancient sea had receded, leaving a coastal plain, low and flat in every direction, and in time—geologic time—rivers and streams cut across the flat plain, meandering down from the highlands to the north, flowing south toward the sea. One particular stream rose from springs and rainfall in the plains and flowed eastward, eventually discharging its waters into a large, shallow bay, southeast of where our city stands today. In time, this stream would come to be known as Río Cibolo, and later as Buffalo Bayou.

The first humans to frequent the area were native American Indians—including the wild, naked Karankawa and the wandering Atakapan—who came mostly during the winters, when herds of buffalo grazed along the bayous. The earliest European travelers to pass through the area—Spanish and French expeditions of the late 17th century—made little effort to describe the place, being more intent on making sure that the other did not establish unrivaled claim to the territory. By 1722 Spain had gained undisputed claim to the frontierland that would eventually be known as Texas.

It wasn't until the early 19th century that memorable impressions of the landscape of the place were recorded. What early travelers and settlers described in their journals and letters was a wild, beautiful, unspoiled land. They found enormous forests of evergreens and hardwood trees, vast prairies of waving grass—grass of such height that men could wander in circles for days—and canebreaks growing, as one visitor observed, "so high as to shut out the view of the sky and every terrestrial object."

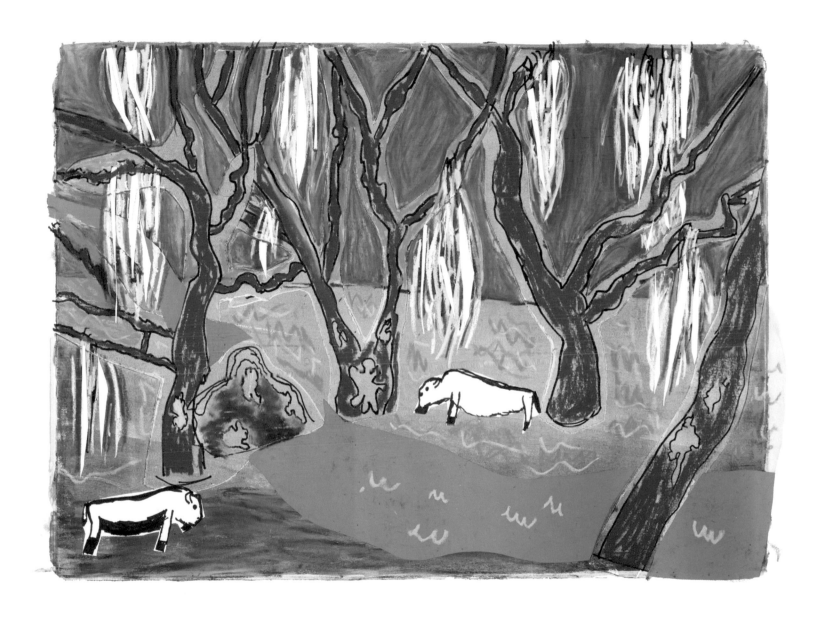

Monoprint with collage, color pencil, markers, and pastel
by Reilley Jones
Fourth Grade, Mark Twain Elementary School

The Original Bayou

One of the features of the place that deeply impressed these early travelers was the Río Cibolo, the stream we now call Buffalo Bayou. One observer, Nicolas Clopper of Cincinnati, arriving on his schooner in 1827, wrote in his journal that "the ebbing and flowing of the tide . . . [give] to this enchanting little stream the appearance of an artificial canal in the design and course of which Nature has lent her masterly hand; . . . most of its course is bound in by timber and flowering schrubbery which overhang its grassy banks and dips and reflect their variegated hues in its unruffled waters."

A decade later, the renowned artist and naturalist John James Audubon traveled along Buffalo Bayou, studying and painting the rich abundance of bird life along its wooded shores.

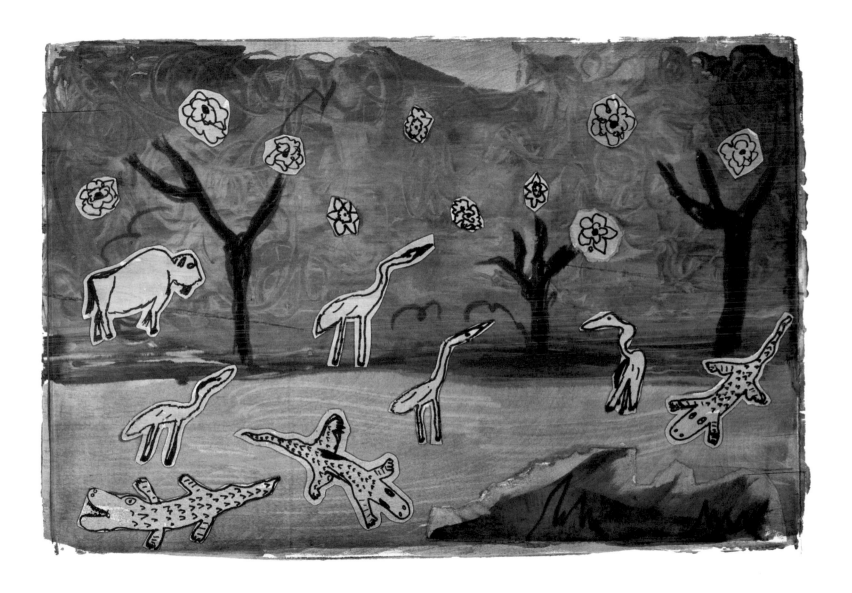

Monoprint with collage, color pencil, markers, and pastel
by Reilley Jones
Fourth Grade, Mark Twain Elementary School

The Animals of the Ancient Bayou

In April of 1826, on the banks of Buffalo Bayou, General Sam Houston and the Texian army surprised the Mexican army under General Santa Anna and won a stunning victory, establishing Texas' independence from Mexico.

In the wake of the victory, two enterprising New York land speculators, the Allen brothers, Augustus Chapman and John Kirby, wasted no time pursuing an entreprenurial venture that would lead to the founding of Houston. When they learned that there was a half-league of land for sale upstream at the highest reach of the tide on Buffalo Bayou, they bought it immediately, sight unseen. Then they hired a steamboat and went to have a look at their property.

The story is that Augustus Allen, the elder brother, strode ashore at the site of our future city, wearing a two-foot beaver top hot. His vision of the city-to-be was so all-absorbing that he likely never noticed the swarms of mosquitoes that must have descended upon him or the sinkholes and alligator wallows in the swampy land all around him. He found a tree stump, sat down, and took out his goosequill pen, ink, and paper. Right then and there, he sketched out the town-to-be, using his beaver top hat for a table.

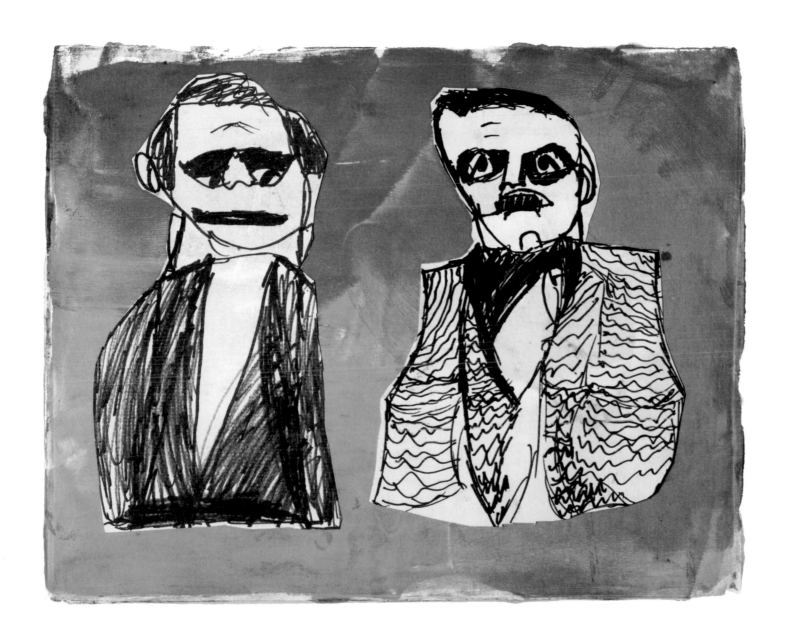

MONOPRINT WITH MARKERS
BY ELIAS BLAIR
Fourth Grade, Wilson Montessori School

Portrait of the Allen Brothers

Four days after purchasing the land, the Allens announced the opening of their town site and began promoting the sale of property. Announcements appeared in newspapers as far away as New York and Atlanta, describing the place and its many virtues, real and imagined, for the purpose of land sales: "It is handsome and beautifully elevated," they advertised, "salubrious and well-watered, and now in the very heart or centre of population. . . ." In June of 1836, Mrs. Dilue Harris, who had settled with her family just south of the new town site, wrote this in her Reminiscences:

> *The new town laid out by the Allens was named Houston, in honor of General Houston. There were circulars and drawings sent out, which represented a large city, showing churches, a courthouse, a market house and a square of ground set aside for a building for Congress, if the seat of government should be located there. . . . There was so much excitement about the city of Houston that some of the young men in our neighborhood, my brother among them, visited it.*

> *. . . they said it was hard work to find the city in the pine woods; and that, when they did, it consisted of one dugout canoe, a bottle gourd of whiskey, and a surveyor's chain and compass, and was inhabited by four men.*

Photograph by Scout Sustala
Sixth Grade, Pershing Middle School

Cruising Buffalo Bayou, East of Downtown Houston

PHOTOGRAPH BY ALEK BLAIR
Fourth Grade, Wilson Montessori School

On Buffalo Bayou, East of Downtown

Monoprint with marker
by Heinrich Duarte
Third Grade, Love Elementary School

Portrait of Sam Houston

In the 1840s and '50s, as Houston began to grow, Galveston had already emerged as Texas' largest city and one of the busiest ports in the entire country. Travelers wishing to reach Houston, for whatever reason, had only two possible routes: either by horseback or wagon train on a slow, arduous overland journey or by steamboat from Galveston up Buffalo Bayou. Amelia Murray's description of her journey up the bayou to Houston in April of 1855 provides a vivid image of travel in that time and place:

> We left Galveston in the Houston steamer at four o'clock to go fifty miles up the bay and forty miles up the bayou to Houston. . . . It was a bright, starlight night when we ascended that which leads from Galveston bay inland. . . . Our steamer, near two hundred feet long, was navigated the whole way through a channel hardly more than eighty feet wide. . . . Negroes holding braziers of blazing pinewood, stood on each side of the vessel, illuminating our passage, the foliage and even the beautiful flowers so near that we could almost gather them as we floated by; a small bell was ringing every instant, to direct our engineers; one moment the larboard paddle, then the starboard was stopped or set in motion, or the wheels were altogether standing still, while we swung around the narrow corners of this tortuous channel; the silence of the bordering forests broken alone by the sobs of our high-pressure engine
> . . . Now and then a night bird, or a frog croaking with a voice like that of a watchman's rattle, accompanied the bells and the escape valve. But human voices were awed into silence during our solemn progress, which seemed to me to belong to neither the sea nor the earth.

Monoprint with collage, color pencil, markers, and pastel
by Makenna Lee
Fourth Grade, Mark Twain Elementary School

Steamboats Traveling Buffalo Bayou

PHOTOGRAPH BY ESTEPHANIA ESPINOZA
Sixth Grade, Lanier Middle School

Reflections in the Waters of Buffalo Bayou

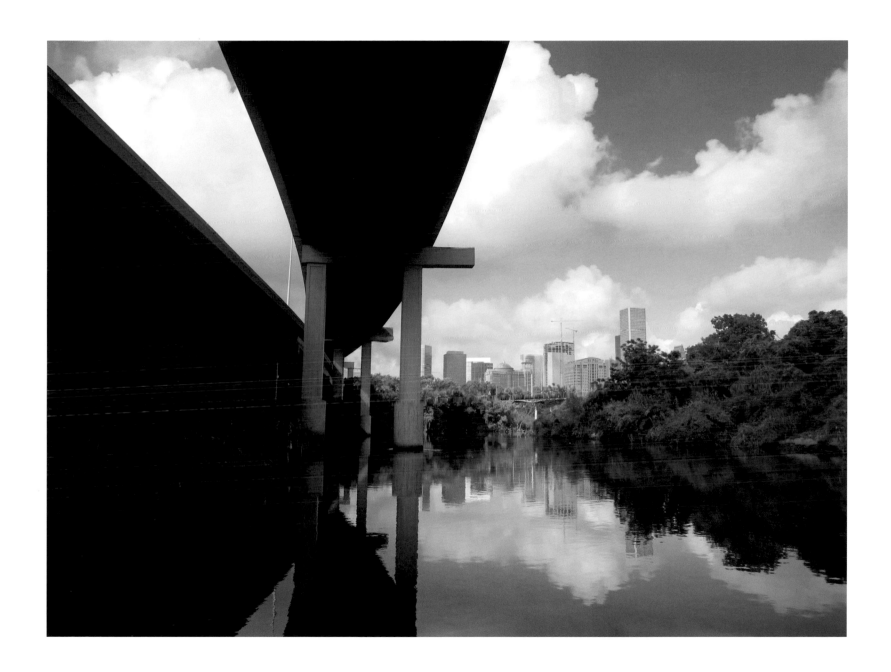

PHOTOGRAPH BY ALEK BLAIR
Fourth Grade, Wilson Montessori School

Approaching Downtown Houston on Buffalo Bayou

The Allen brothers named their town after General Sam Houston and then persuaded the Texas Congress to designate it as the temporary capital of the new Republic of Texas. In January of 1837, the new town and state capital had only 12 residents and one log cabin; but its growth, from the beginning, was impressive. Four months later, there were several hundred residents and 100 homes. The town was surveyed in gridiron fashion, with broad streets running parallel and perpendicular to the bayou. Small lots sold for up to $5,000 each, an astonishingly high price for the time.

Houston quickly gained notoriety as a rowdy and colorful place. As *The Nation* reported, "By the end of 1837, Houston had 1200 residents, a theatre, 50 gambling houses, nearly 100 saloons, and no house of worship."

The seat of the Texas government was moved out of Houston to Austin in 1839, but that did little to slow the growth of the city. Cotton, timber, and railroad industries were established. Ocean-going ships brought cargoes to Galveston from around the world, river steamships took the goods from Galveston up Buffalo Bayou to Houston, and Houston merchants sent them out by ox wagon to farmers in surrounding territories. By the turn of the century, Houston was a true center of commerce, just as the Allen brothers had advertised it would be.

By 1900, the population of Houston had grown to 45,000, making it the 85th largest city in the United States. The Spindletop gusher blew near Beaumont on January 10, 1901. The next one hundred years brought even more astonishing growth, as the city's population grew to 2.1 million by the year 2010, the fourth largest city in the country.

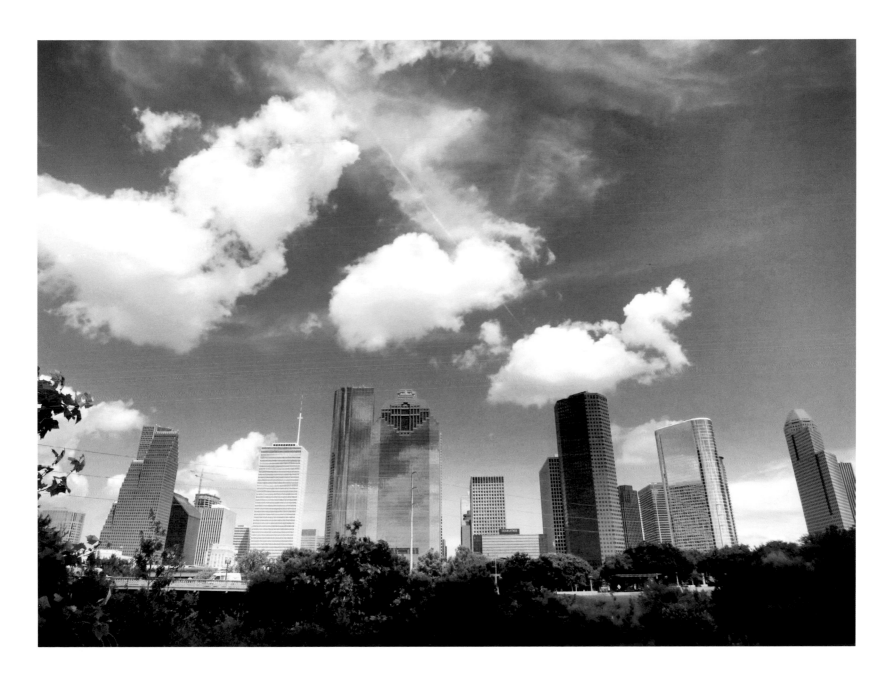

PHOTOGRAPH BY ANNALISE ROSENBAUM
Eighth Grade, The Rusk School

Downtown Houston from Buffalo Bayou

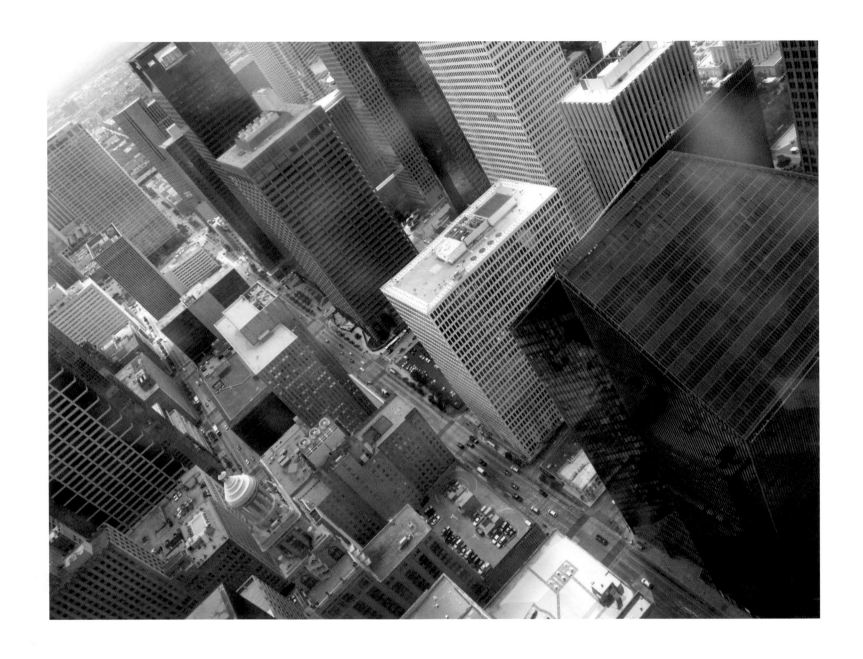

PHOTOGRAPH BY JAYLEN DAVIS
Fifth Grade, Love Elementary School

Louisiana Street in Downtown Houston

PART II: HOUSTON TODAY

After the oil boom collapse in 1982, the city's continued growth was due primarily to the influx of African-Americans, Asians, and Hispanics. Today, Houston is the most ethnically diverse city in the country. More than 90 languages are spoken, and over 100 distinct ethnic groups shape the city's diverse social and cultural life.

While "Greater Houston" extends more than 600 square miles, the area that we call "Downtown" covers only 1.84 square miles, an island of skyscrapers, parks, restaurants, hotels, theaters, retail and government buildings, sports facilities, and residential developments. Each workday, over 148,000 men and women go to work at one of 3,500 businesses in Downtown Houston.

Ninety-two countries from around the world have established consular offices in Houston. More than 500 cultural, visual, and performing arts organizations are located in the central city.

PHOTOGRAPH BY ALYSSA VÁSQUEZ
Fifth Grade, Love Elementary School

Miss Ducky (above)

PHOTOGRAPH BY MARÍA MARTÍNEZ
Fifth Grade, Love Elementary School

Looking Down the Skyscraper (right)

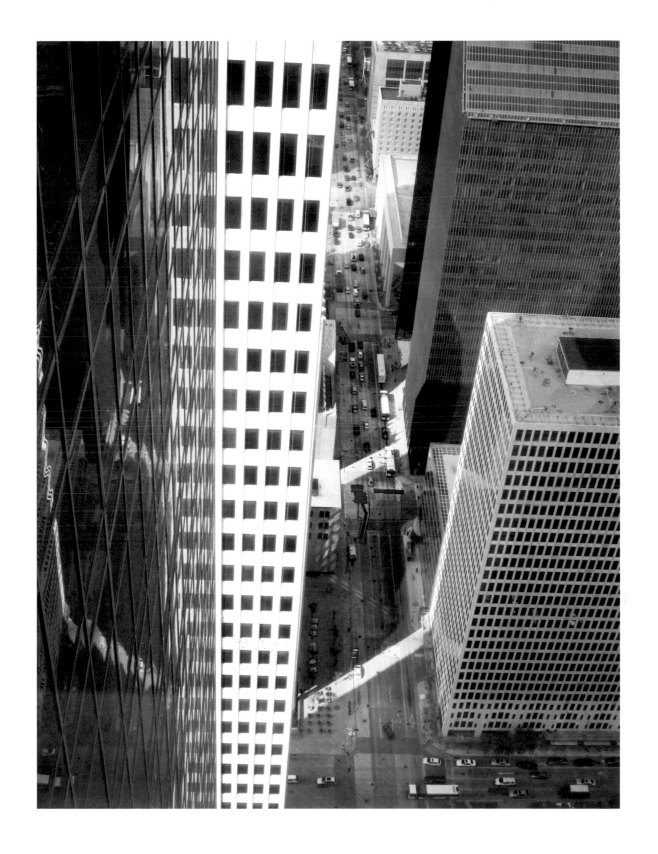

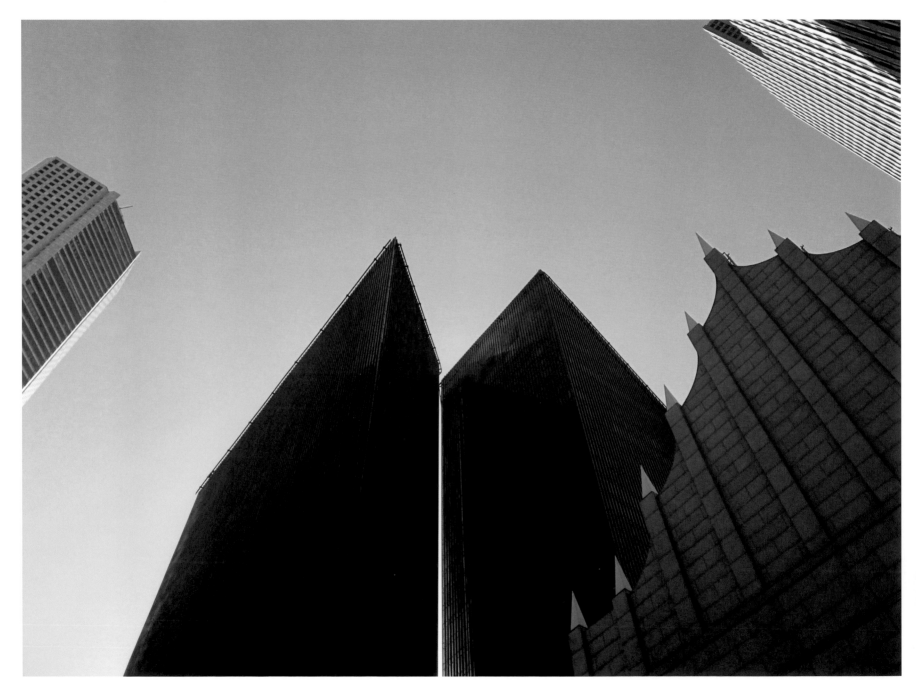

PHOTOGRAPH BY Robel Tesfamichael
Eighth Grade, Las Americas Middle School

The Leaning Towers

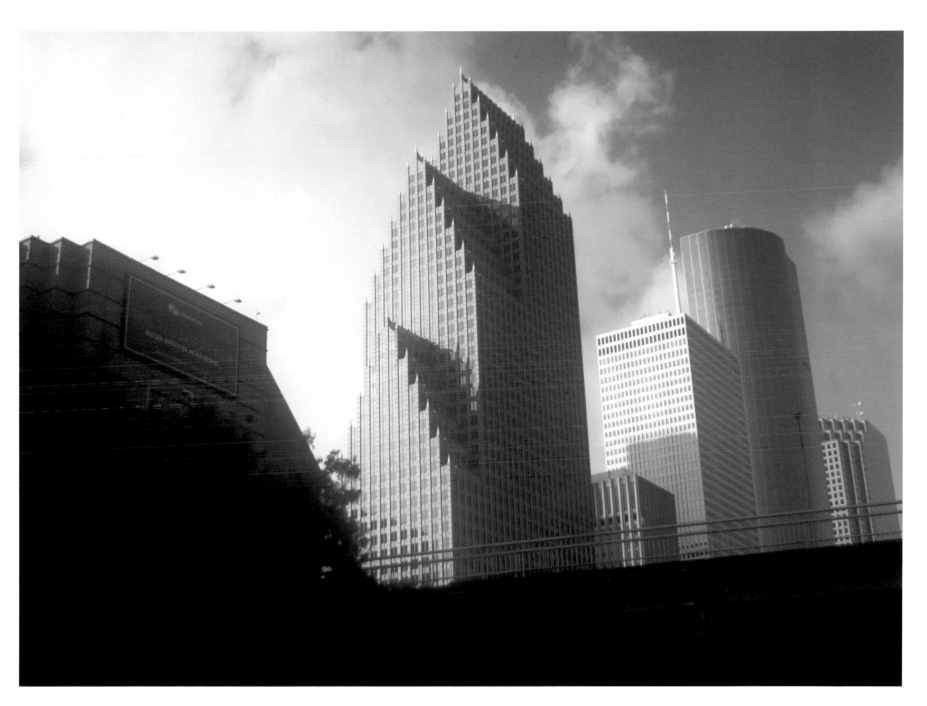

PHOTOGRAPH BY SCOUT SUSTALA
Seventh Grade, Pershing Middle School

City Building Blocks

Photographs by Victoria Ortega
Fifth Grade, Love Elementary School

Pennzoil Place (above)
Downtown Bird (right)

PHOTOGRAPH BY ABIGAIL OYERVIDEZ
Fourth Grade, Wilson Montessori School

The Colors of the Street

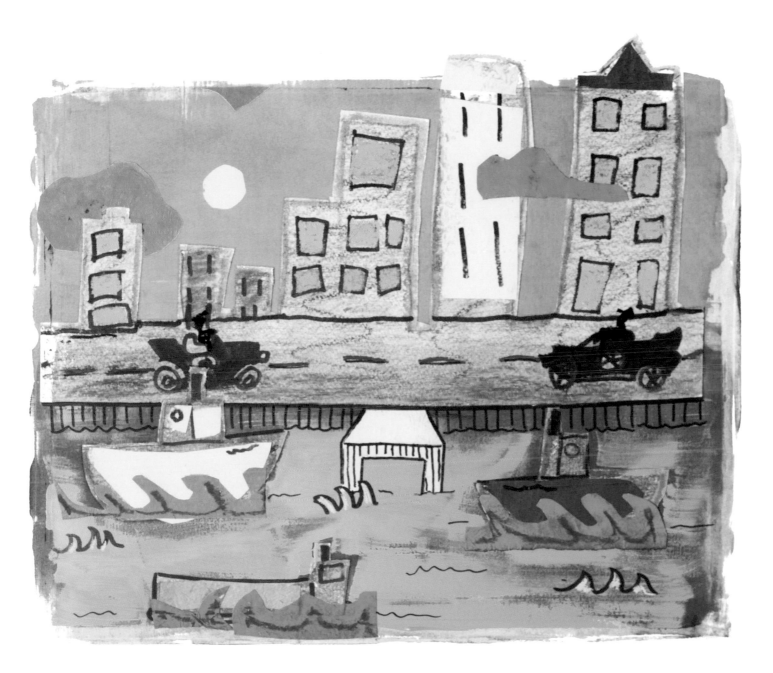

MONOPRINT WITH COLLAGE, COLOR PENCIL, MARKERS, AND PASTEL
BY REBECCA WOLFARTH
Fourth Grade, Wilson Montessori School

Houston on the Bayou

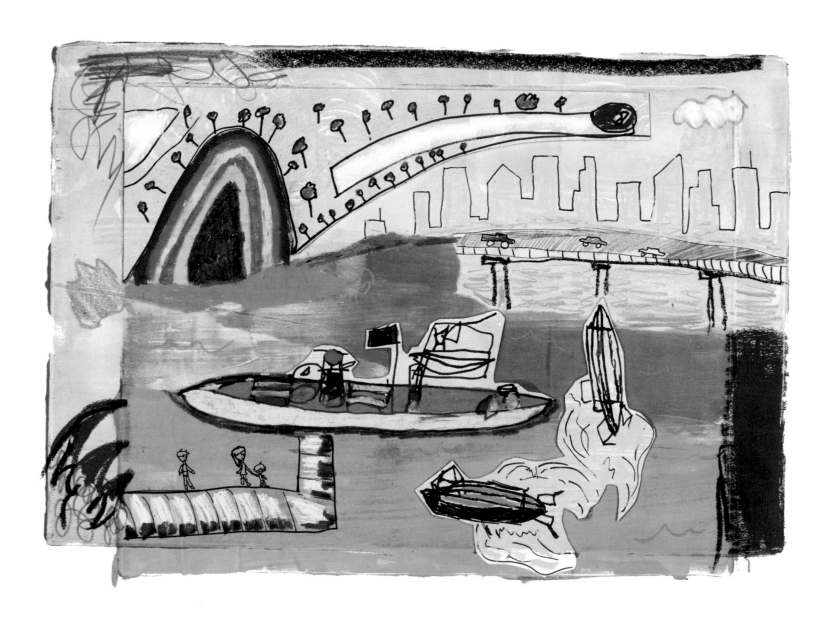

Monoprint with collage, color pencil, markers, and pastel
by Starla Sánchez
Fourth Grade, Mark Twain Elementary School

All About Houston

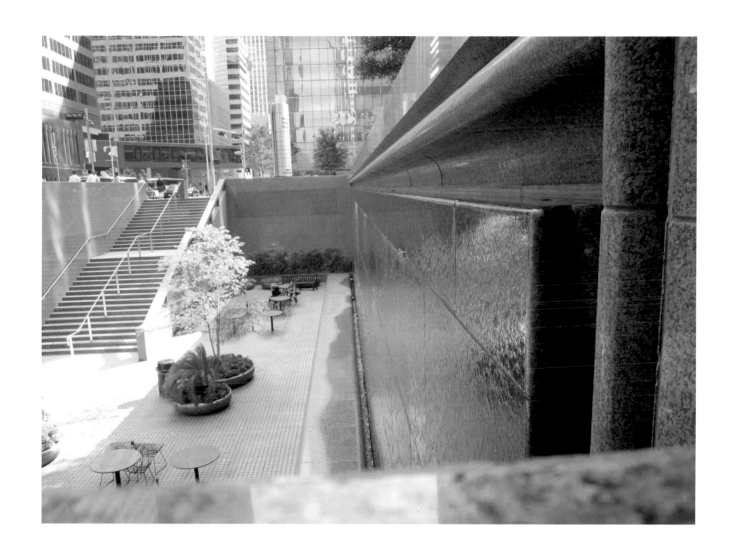

PHOTOGRAPH BY DAMIEN VILLARREAL
Fifth Grade, Love Elementary School

1000 Louisiana Street

PHOTOGRAPHS BY ALEK BLAIR
Fourth Grade, Wilson Montessori School

Corner of Louisiana and Walker Streets (above)
Corner of Louisiana and Rusk Streets (right)

PHOTOGRAPH BY GEORGIE RAWSON
Third Grade, Mark Twain Elementary School

Wall of Mirrors (above)

PHOTOGRAPH BY DOMINICK REYES
First Grade, Love Elementary School

Preston Street (right)

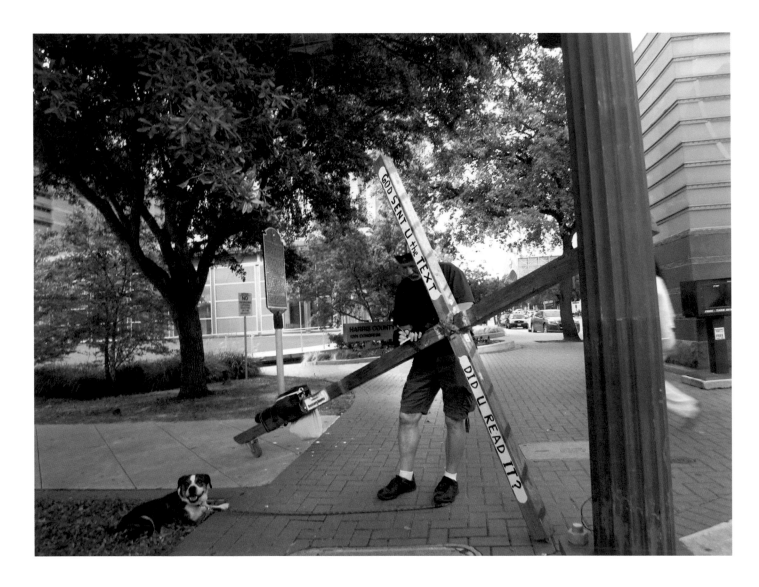

PHOTOGRAPH BY KENNEDY SERVÍN
Fifth Grade, Love Elementary School

Did U Read It? (above)

PHOTOGRAPH BY GEORGIE RAWSON
Third Grade, Mark Twain Elementary School

On the Way to Comic-Con, George Brown Convention Center (right)

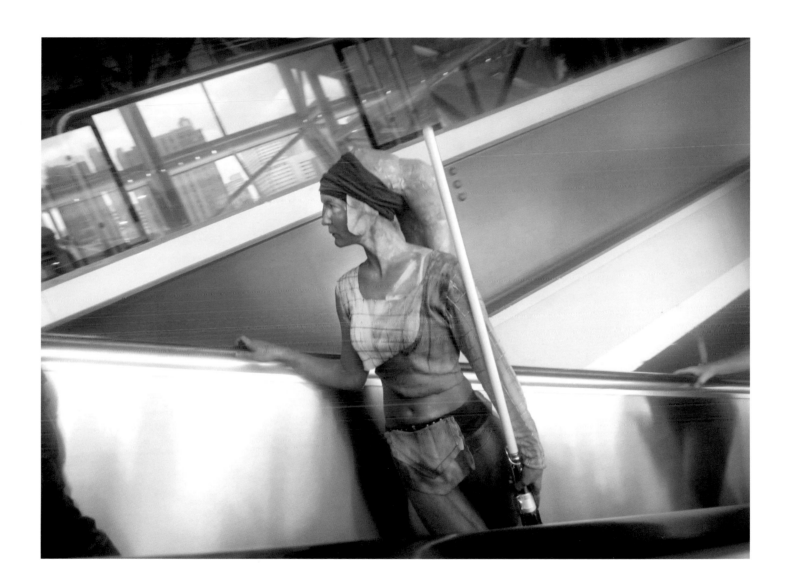

Photograph by Alejandro Santillán
Third Grade, Lanier Middle School

Reflections Under the Swinging Bridge (above)

Photograph by Heinrich Duarte
Third Grade, Love Elementary School

Walking Home, Watched (right)

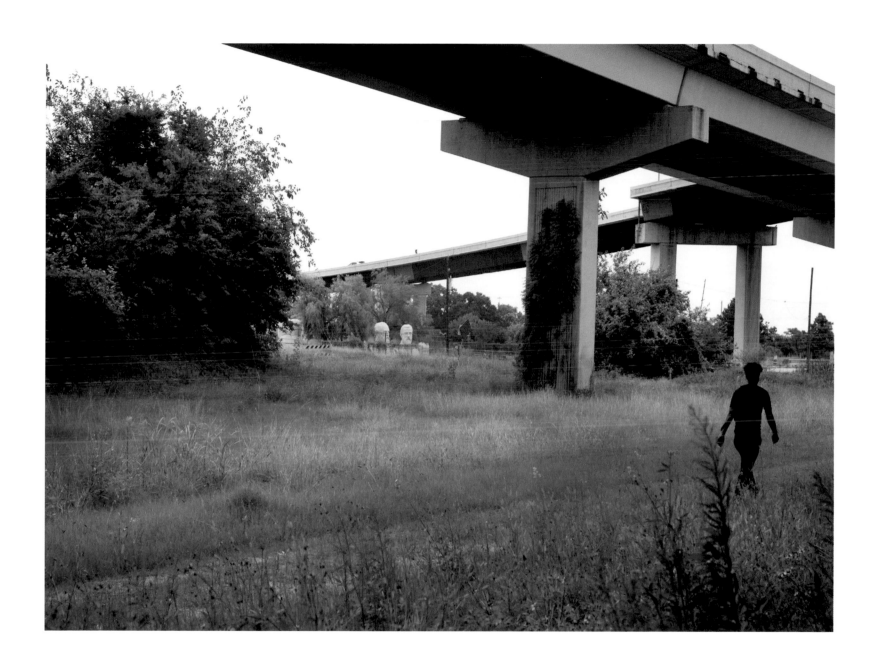

PHOTOGRAPH BY HARPER GILBERT
Fifth Grade, Wilson Montessori School

The Secret (above)

PHOTOGRAPH BY ALEJANDRO SANTILLÁN
Third Grade, Love Elementary School

At the Adickes Studio (right)

PHOTOGRAPH BY ALEJANDRO SANTILLÁN
Third Grade, Love Elementary School

*Notsuoh Cafe on Main Street
(upper left)*

PHOTOGRAPH BY HARPER GILBERT
Fifth Grade, Wilson Montessori School

*Notsuoh Cafe on Main Street
(upper right and facing page)*

PHOTOGRAPH BY GEORGIE RAWSON
Third Grade, Mark Twain Elementary School

*Notsuoh Cafe on Main Street
(lower left and right))*

PHOTOGRAPH BY MARTHA SANDOVAL
Third Grade, Love Elementary School

The Three Bushes, Sabine Street

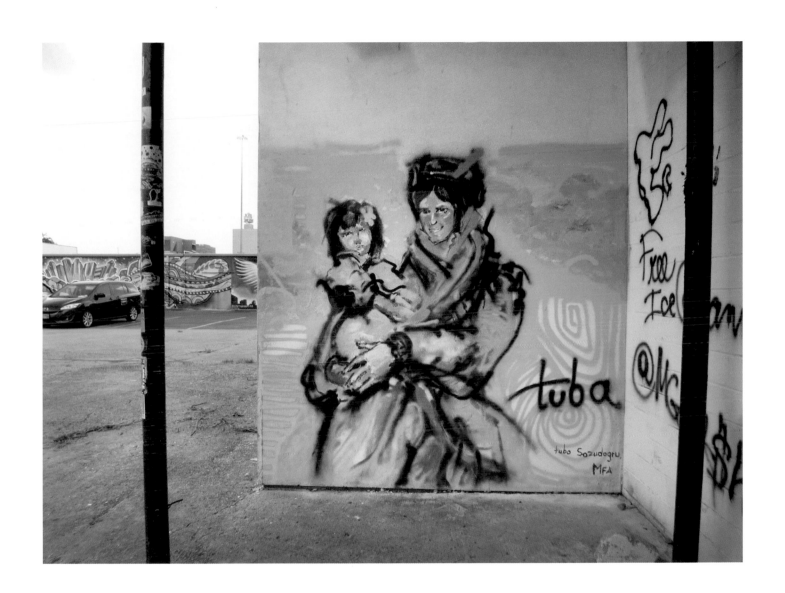

Photograph by Alondra Reyes
Third Grade, Love Elementary School

Mother and Child Graffiti, Holman Street

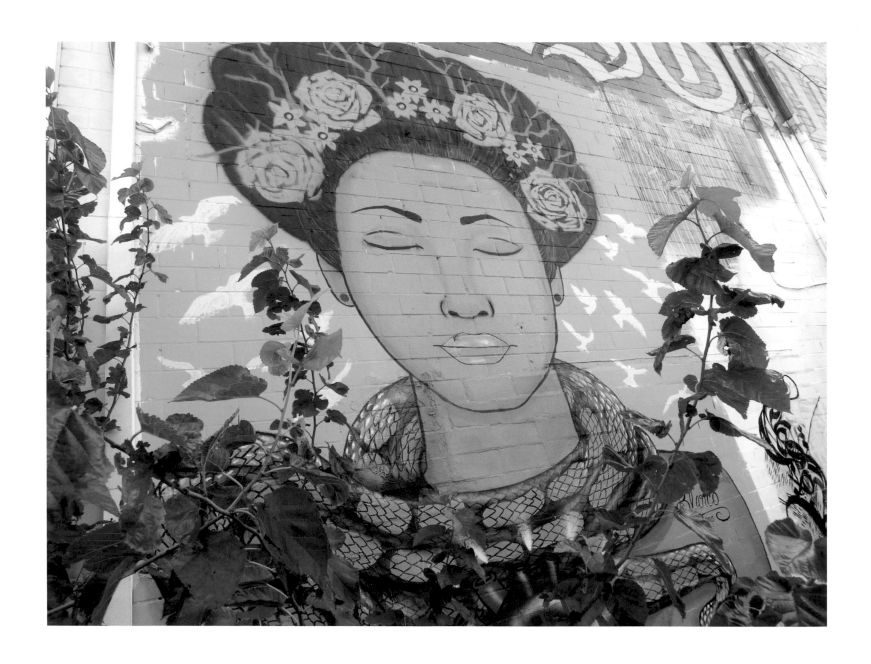

PHOTOGRAPH BY ANNALISE ROSENBAUM
Eighth Grade, The Rusk School

Snake Necklace, Holman Street

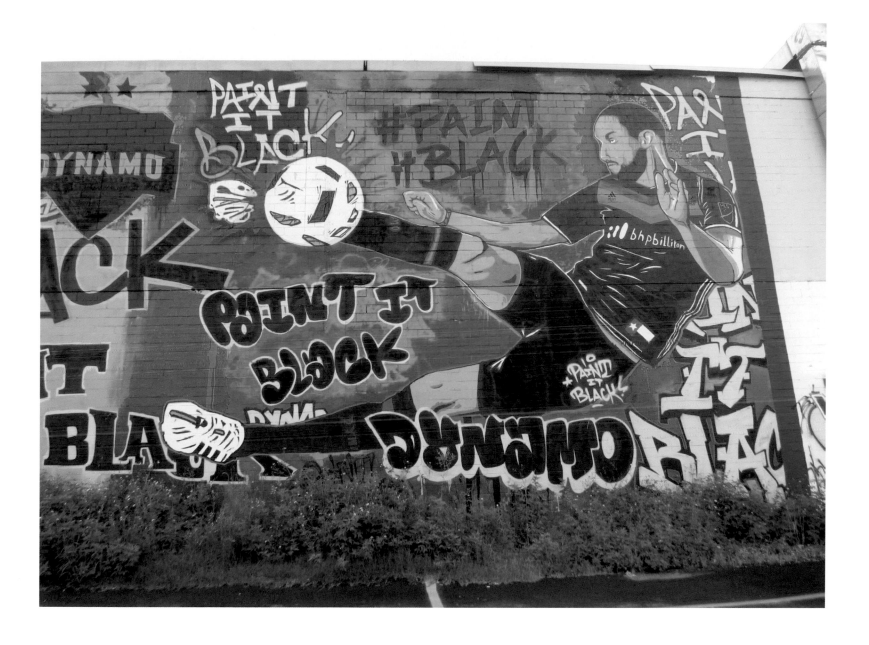

Photograph by Alondra Reyes
Third Grade, Love Elementary School

Paint It Black, Holman Street

PHOTOGRAPH BY GRETA LAUDER
Second Grade, Love Elementary School

The Blue Man, Holman Street (above)

LYSANDER (XANDER) VAN DEN NIEUWENHOF PHOTOGRAPHING GRAFFITI *(right)*
Washington Avenue

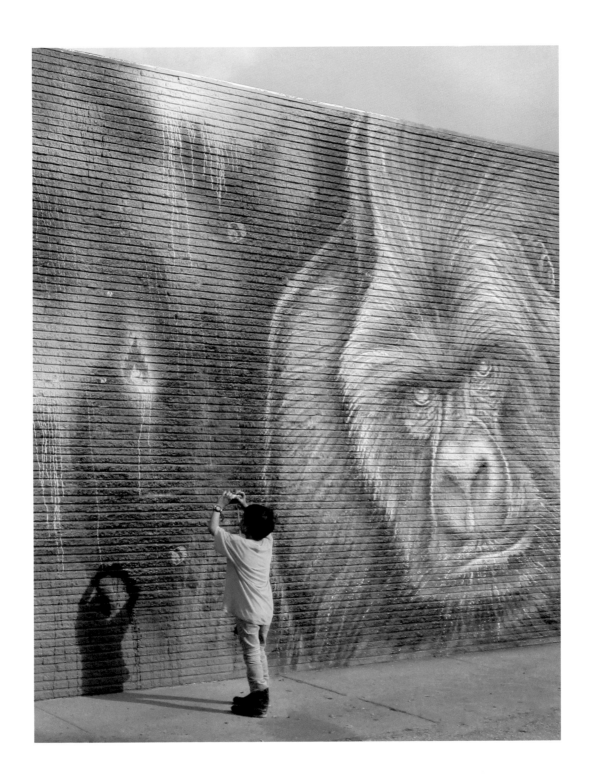

Love Elementary School Kids Photographing at Jamail Skate park (*above*)

Photograph by Lysander (Xander) Van den Nieuwenhof
Second Grade, Love Elementary School

Jamail Skate Park (right)

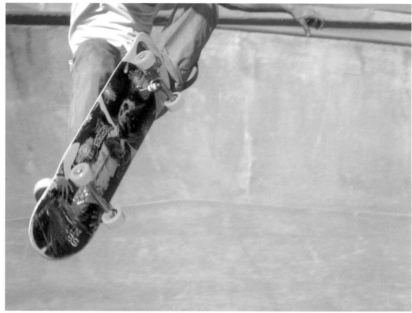

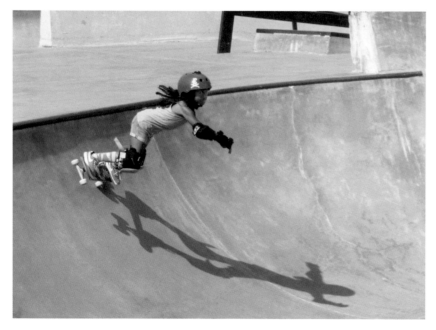

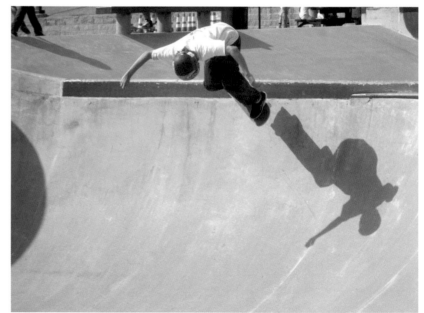

PHOTOGRAPH BY MARTHA SANDOVAL
Third Grade, Love elementary School

Skateboarding (upper left)

PHOTOGRAPH BY SOPHIA VU
Fourth Grade, Love Elementary School

Skateboarding (lower left)

PHOTOGRAPH BY KELLY RIVERA
Seventh Grade, Hamilton Middle School

Skateboarding (upper right)

PHOTOGRAPH BY MAURICIO RIVERA
Third Grade, Love Elementary School

Skateboarding (lower right)

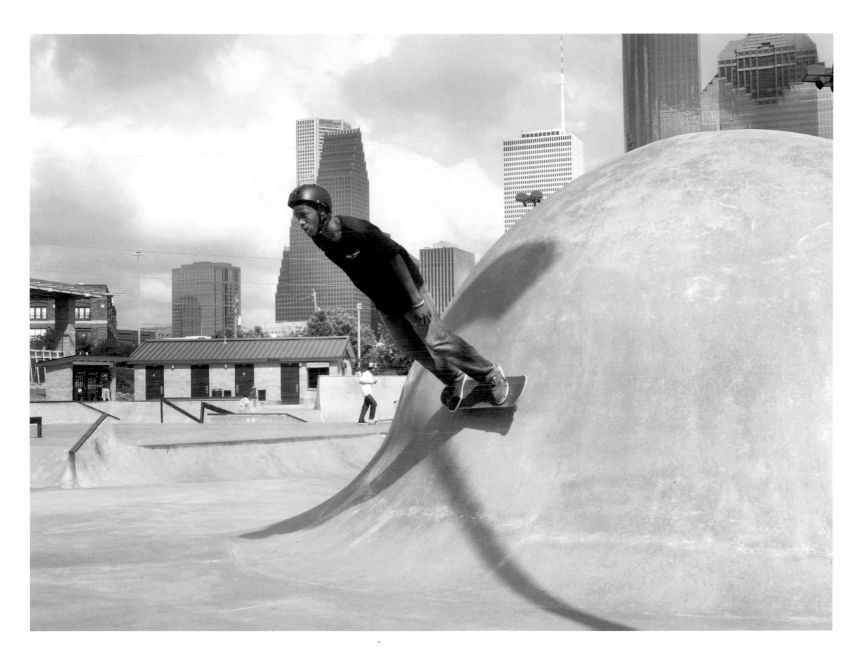

Photograph by Sophia Vu
Fourth Grade, Love Elementary School

Skateboarding

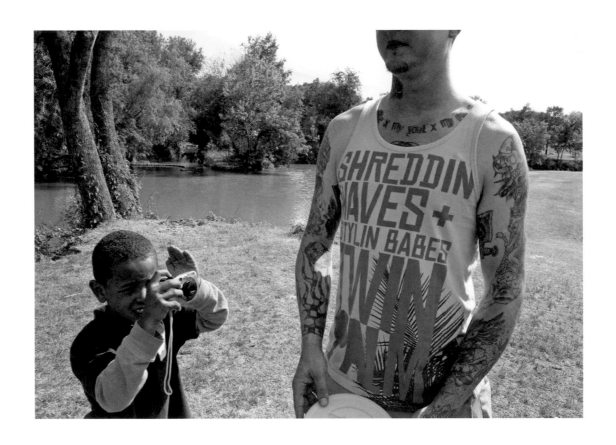

Terrance (T. J.) Washington Photographing a Tattooed Man *(above)*

Photograph by Terrance (T. J.) Washington
Kindergarten, Love Elementary School

Tattooed Hand (right)

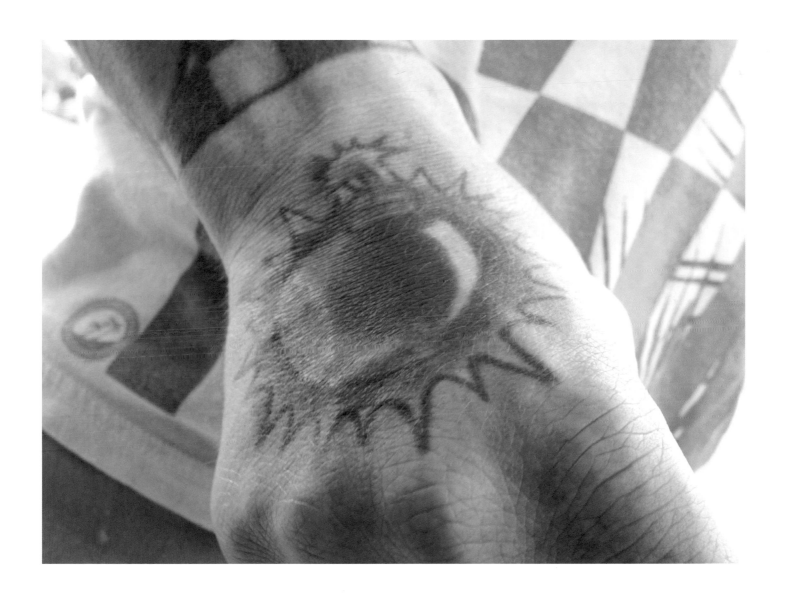

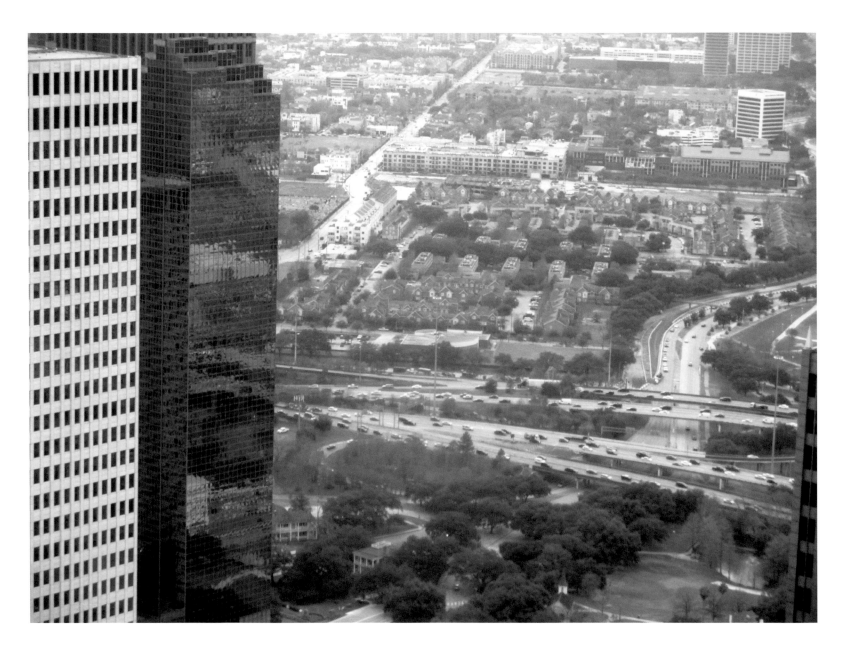

PHOTOGRAPH BY DANIELA DÍAZ
Fourth Grade, Kipp Zenith Academy

The Living City

PART III: FREEWAYS AND CITY STREETS

When the Gulf Freeway was opened in 1948, connecting Houston and Galveston, it was the first freeway in Texas. Today, Greater Houston is one of the most automobile-dependent urban area in the country, with 740 miles of freeways.

The city's freeway system has been described as a "hub and spoke" layout with concentric loops. The innermost loop is Interstate 610, a roughly 10-mile diameter circuit around Downtown. Interstate 610 is quartered into "North Loop," "South Loop," "West Loop," and "East Loop."

Beltway 8 and the Sam Houston Tollway form the outer loop (aka: The Grand Parkway), at a diameter of about 25 miles. These two loops around the city are connected at strategic points by more expressways and interstate highways. Interstate 10 at Gessner Road, 26 lanes across, is said to be the widest freeway in the world.

Generally speaking, Houstonians consider anything "Inside The Loop" as within the center of the city, anything "Outside The Loop" as farther away from the center, and anything "outside the beltway"as suburbia.

PHOTOGRAPH BY REBECCA WOLFARTH
Fourth Grade, Wilson Montessori School

City from the Car Window (above)

PHOTOGRAPH BY ALANIS CASTAÑO
Eighth Grade, Lanier Middle School

Buildings in the Forest (right)

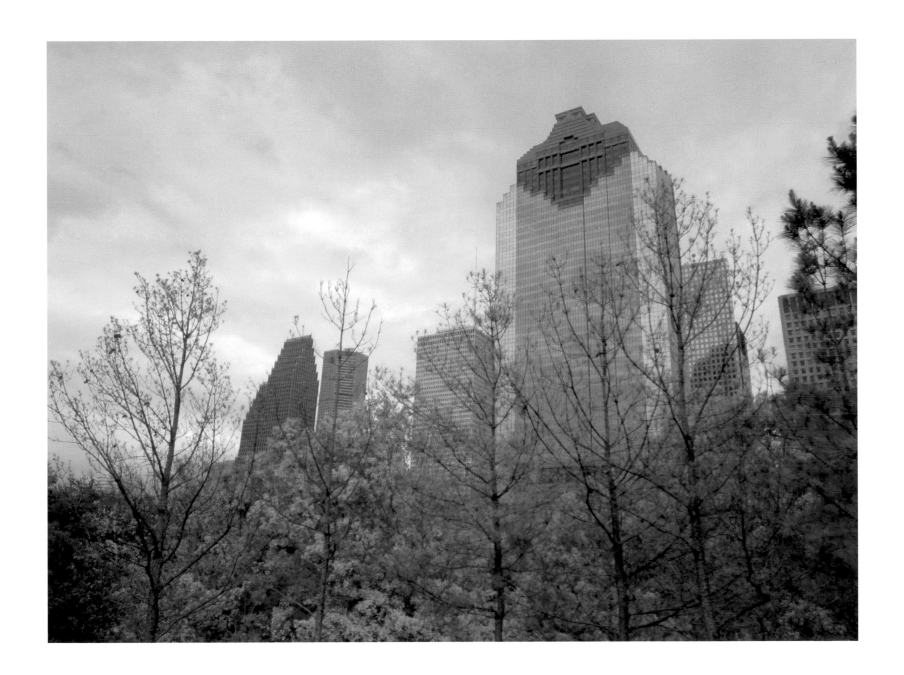

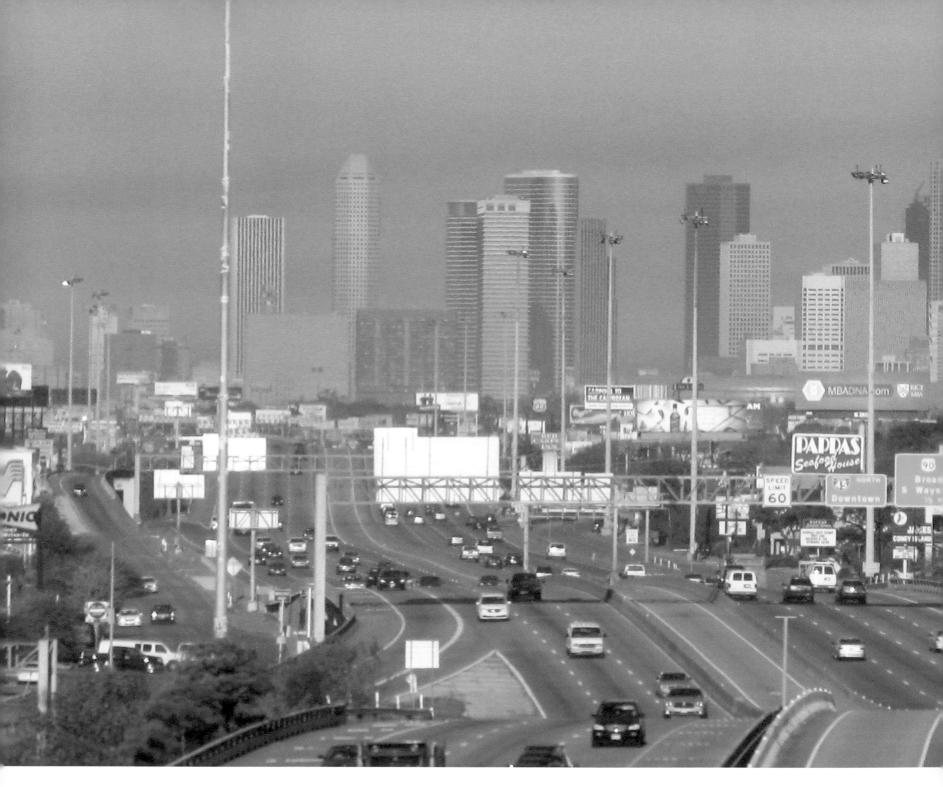

PHOTOGRAPH BY ROBEL TESFAMICHAEL
Seventh Grade, Las Americas Middle School

On the South Freeway into Houston

PHOTOGRAPH BY ALONDRA REYES
Third Grade, Love Elementary School

On the 610 Freeway

PHOTOGRAPH BY ANNALISE ROSENBAUM
Eighth Grade, The Rusk School

On the 610 Freeway

PHOTOGRAPH BY ANNALISE ROSENBAUM
Eighth Grade, The Rusk School

On the 610 Freeway

PHOTOGRAPH BY ELIAS BLAIR
Fourth Grade, Wilson Montessori School

On the 610 Freeway

PHOTOGRAPH BY ALICIA MELÉNDEZ
Fourth Grade, Wilson Montessori School

Houston Avenue at White Oak Drive

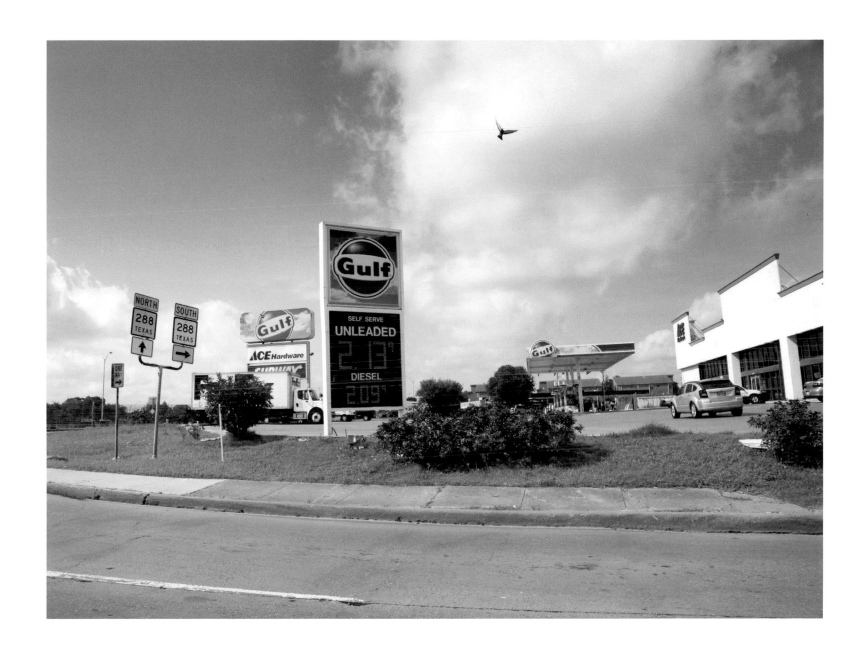

Photograph by Rebecca Wolfarth
Fourth Grade, Wilson Montessori School

South McGregor Drive at Highway 288

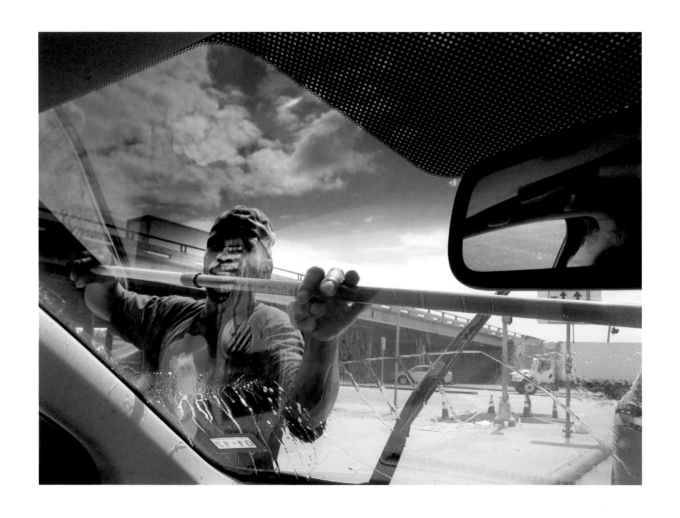

PHOTOGRAPH BY ANNALISE ROSENBAUM
Eighth Grade, The Rusk School
Windshield Washer: Telephone Road at the 610 Freeway (above)

PHOTOGRAPH BY DARIO AVILÁ
Fifth Grade, Love Elementary School

Yale Avenue, Houston Heights (right)

94

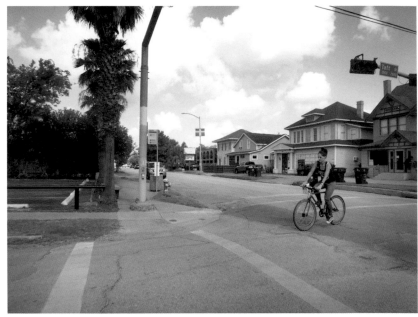

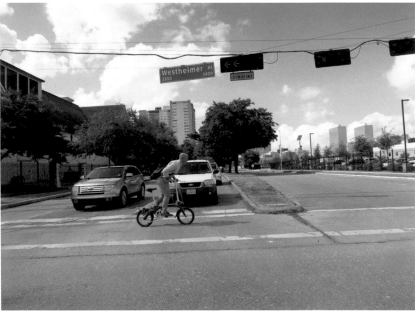

PHOTOGRAPH BY ALICIA MELÉNDEZ
Fourth Grade, Wilson Montessori School

Houston Avenue at Crockett Street (upper left)

PHOTOGRAPH BY KENNEDY SERVÍN
Fifth Grade, Love Elementary School

Westheimer Road at Buffalo Speedway (lower left)

PHOTOGRAPH BY SCOUT SUSTALA
Sixth Grade, Pershing Middle School

Taft Street at Westheimer Road (upper right)

PHOTOGRAPH BY ALONDRA REYES
Third Grade, Love Elementary School

Access Road, Interstate 10 (lower right)

Photograph by Elias Blair
Fourth Grade, Wilson Montessori School

Dunlavy Street at Westheimer Road

PHOTOGRAPH BY FRANCISCO CÁZARES
Fifth Grade, Love Elementary School

Café on Houston Avenue (above)

PHOTOGRAPH BY SCOUT SUSTALA
Seventh Grade, Pershing Middle School

Harvard Street, Houston Heights (right)

PHOTOGRAPH BY SCOUT SUSTALA
Seventh Grade, Pershing Middle School

River Oaks Boulevard at Ella Lee Lane

Photograph by Dominick Reyes
First Grade, Love Elementary School

Ella Lee Lane at Maconda Street, River Oaks

PHOTOGRAPH BY ANNALISE ROSENBAUM
Eighth Grade, The Rusk School

Bellaire Boulevard (above)

PHOTOGRAPH BY ALONDRA REYES
Third Grade, Love Elementary School

Bellaire Boulevard (left)

PHOTOGRAPH BY JONATHAN ARELLANO
Spring Branch Family Development Center

Drive-Thru Restaurant, Long Point Road

PHOTOGRAPH BY ESTEPHANIA ESPINOSA
Sixth Grade, Lanier Middle School

Smoothies at the Sonic (upper left)

PHOTOGRAPH BY KASSANDRA RODRÍGUEZ
Spring Branch Family Development Center

Order Window, Long Point Road (lower left)

PHOTOGRAPH BY LYSANDER (XANDER) VAN DEN NIEUWENHOF
Second Grade, Love Elementary School,

Food Truck (upper right)

PHOTOGRAPH BY GRETA LAUDER
Second Grade, Love Elementary School

Doughnuts! (lower right)

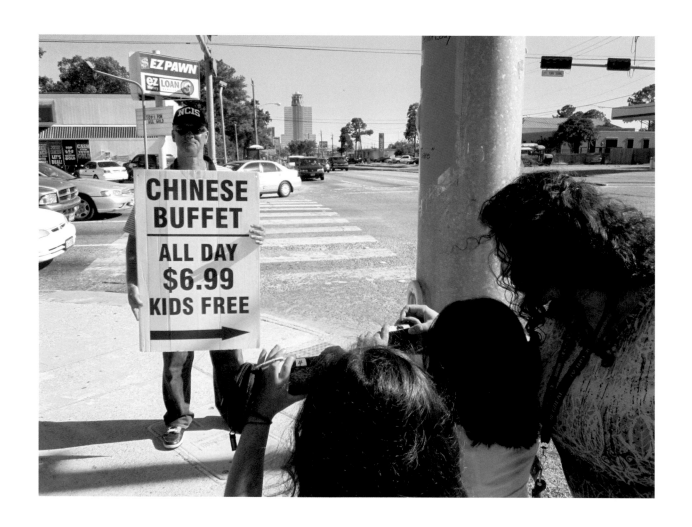

KASSANDRA RODRÍGUEZ AND SHEYLA ORTÍZ PHOTOGRAPHING
ON LONG POINT ROAD *(above)*

PHOTOGRAPH BY KASSANDRA RODRÍGUEZ
Spring Branch Family Development Center

Chinese Buffet Sign Man, Long Point Road (right)

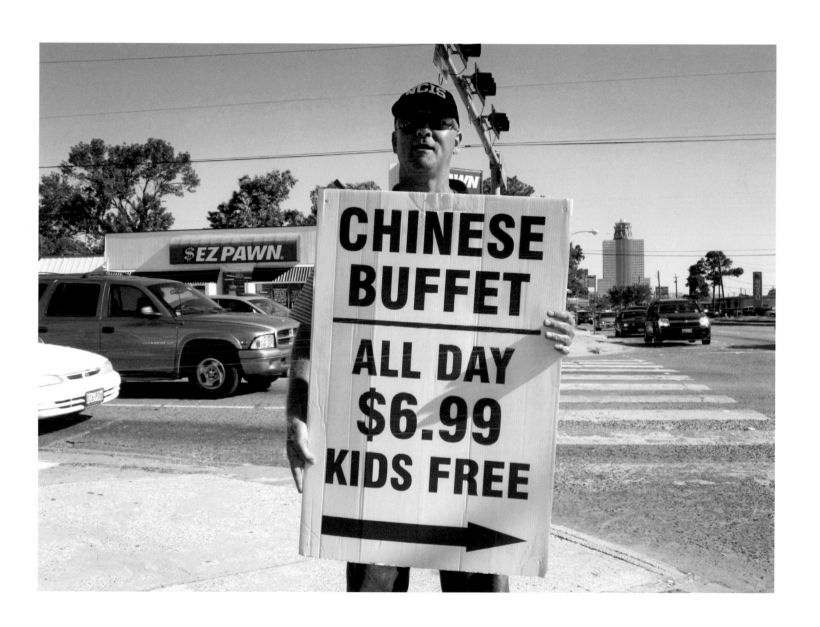

PHOTOGRAPHS BY JONATHAN ARELLANO
Spring Branch Family Development Center

On Long Point Road, Spring Branch

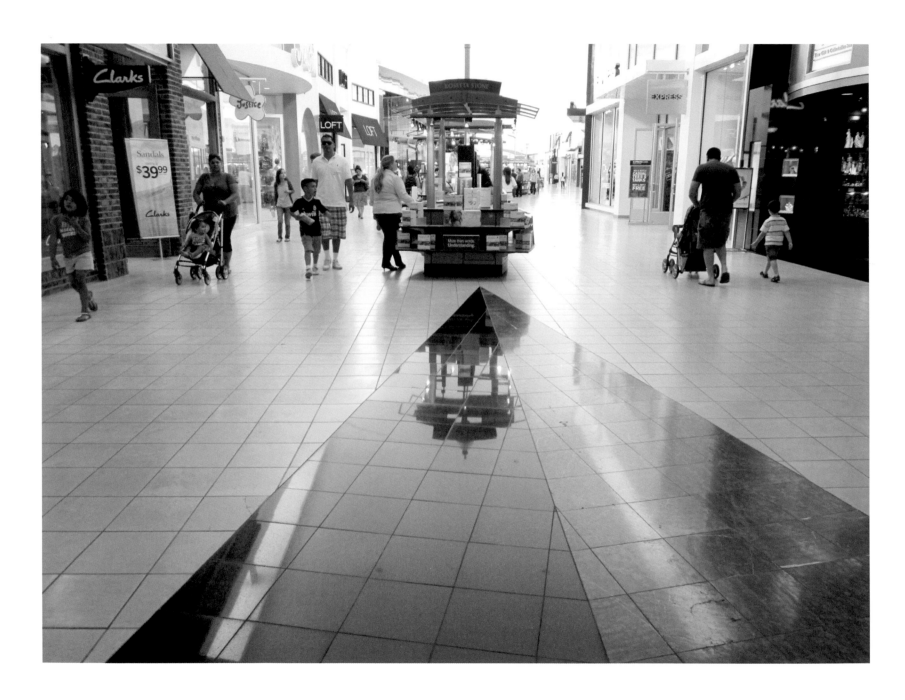

Photograph by Kal-el Haggerty
Spring Branch Family Development Center

Memorial City Mall

Part IV: Markets and Malls

The great markets of Houston are its shopping malls; seventeen major malls operate within the city.

The origin of the shopping mall can be traced to 1954, when the architect Victor Gruen designed Northland Center for suburban Detroit. When Northland opened, it was easily the largest shopping center on the planet. Fifty thousand people a day streamed through its doors.

Over half a century later, Victor Gruen's basic concept provides the foundation for virtually every mall in America: place one or more major stores at anchor points, then arrange a great variety of smaller stores in positions leading to the anchors. The more massive the scale of the mall, the more it allows for large, bustling public spaces and unlimited parking.

Memorial City, Willowbrook, Greenspoint, San Jacinto, First Colony, Gulfgate, Meyerland. Malls dot the landscape of Houston, but they are only the largest of the city's many diverse marketplaces. Giant grocery store chains—HEB, Kroger, Whole Foods—also cover the city. There are specialty markets, many of them with a distinctly ethnic flavor, such as the Canino Produce Market on Airline Drive, which resembles an authentic Mexican *mercado,* and the Hong Kong Mall on Bellaire Boulevard in Houston's Chinatown.

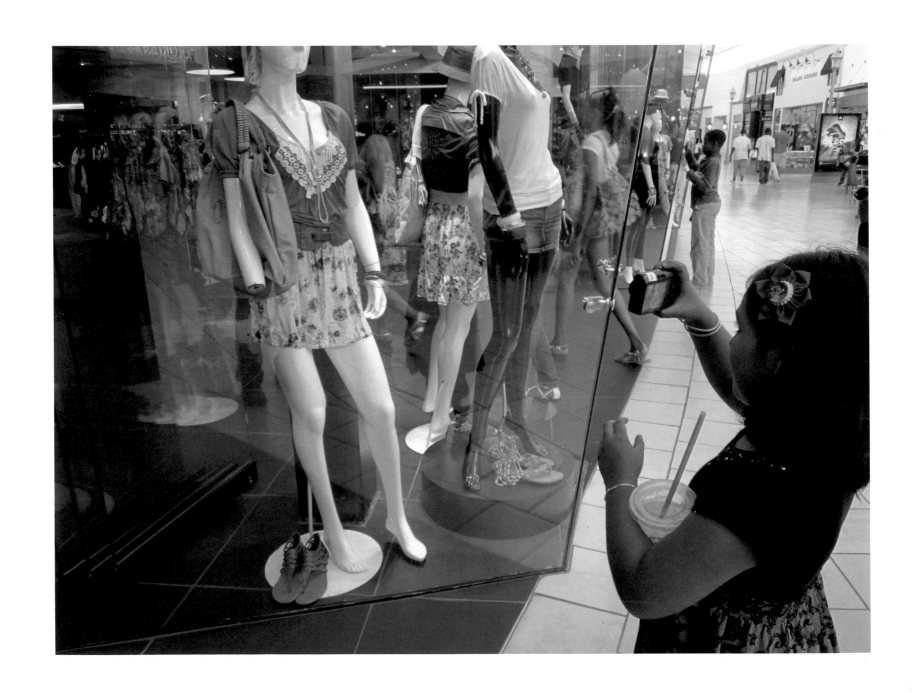

Kassandra Rodríguez Photographing at the Memorial City Mall

PHOTOGRAPHS BY KASSANDRA RODRÍGUEZ
Spring Branch Family Development Center

Window Displays, Memorial City Mall (upper left and right, lower right)

PHOTOGRAPH BY SHEYLA ORTÍZ
Spring Branch Family Development Center

Window Display, Memorial City Mall (lower left)

Photograph by Elle Devine
Kindergarten, Love Elementary School

Fish Department, Kroger Food Market (above)

Photograph by Jaden Washington
Spring Branch Family Development Center

Starbucks, Memorial City Mall (left)

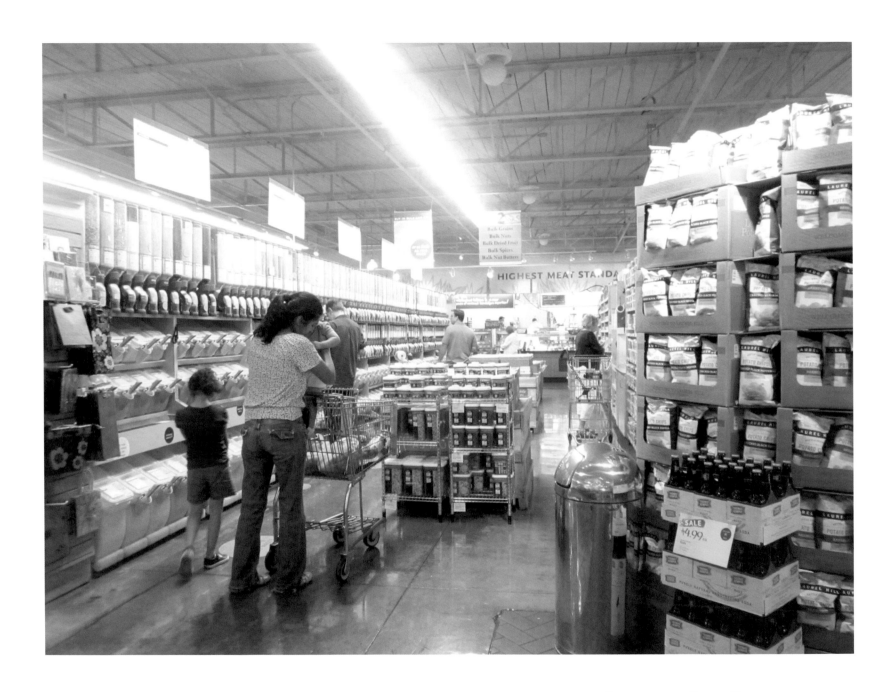

PHOTOGRAPHS BY PATRICK KELLY
Fifth Grade, Mark Twain Elementary School

Whole Foods Market, Bellaire

PATRICK KELLY AND MATHILDA BLACK PHOTOGRAPHING AT WHOLE FOODS MARKET *(above)*

PHOTOGRAPH BY PATRICK KELLY
Fifth Grade, Mark Twain Elementary School

Whole Foods Market, Bellaire (right)

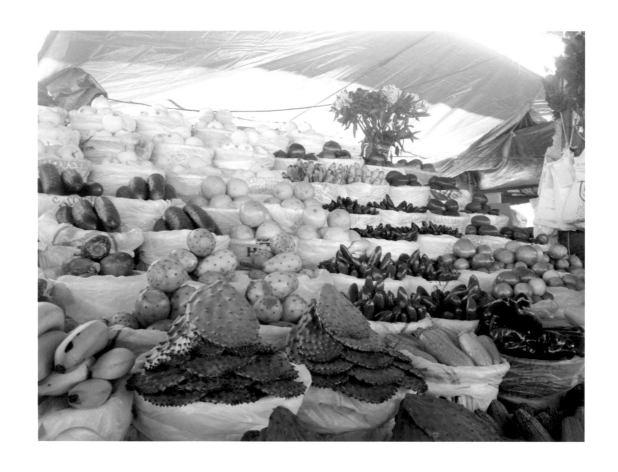

PHOTOGRAPH BY KELLY RIVERA
Fifth Grade, Love Elementary School

Canino Airline Market (above)

PHOTOGRAPH BY DYLAN CASSILLO-BROWN
Third Grade, Love Elementary School

Day of the Dead Altar (right)

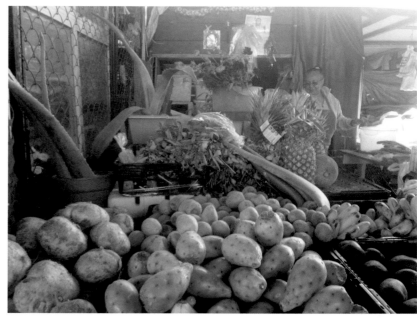

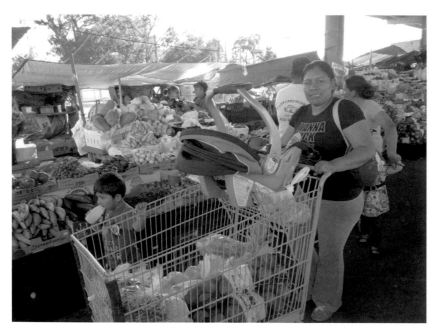

PHOTOGRAPHS BY KELLY RIVERA
Fifth Grade, Love Elementary School
Canino Airline Market (upper left and right, lower left)

PHOTOGRAPH BY STELLA CASSILLO-BROWN
First Grade, Love Elementary School

Canino Airline Market (lower right)

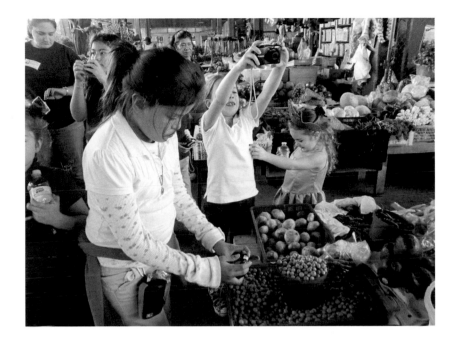

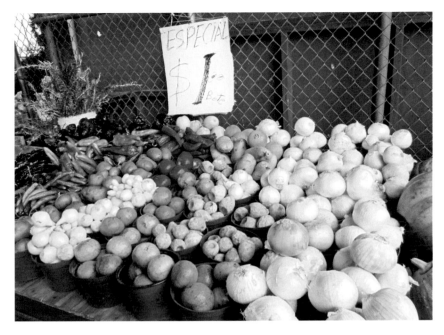

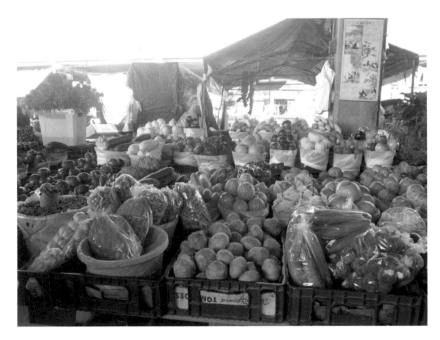

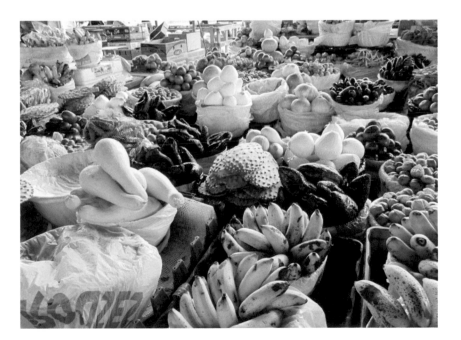

Love Elementary School Students Photographing at
the Canino Airline Market *(upper left)*

Photograph by Kelly Rivera
Fifth Grade, Love Elementary School

Canino Airline Market (lower left)

Photograph by Elle Devine
Kindergarten, Love Elementary School

Canino Airline Market (upper right)

Photograph by Stella Cassillo-Brown
First Grade, Love Elementary School

Canino Airline Market (lower right)

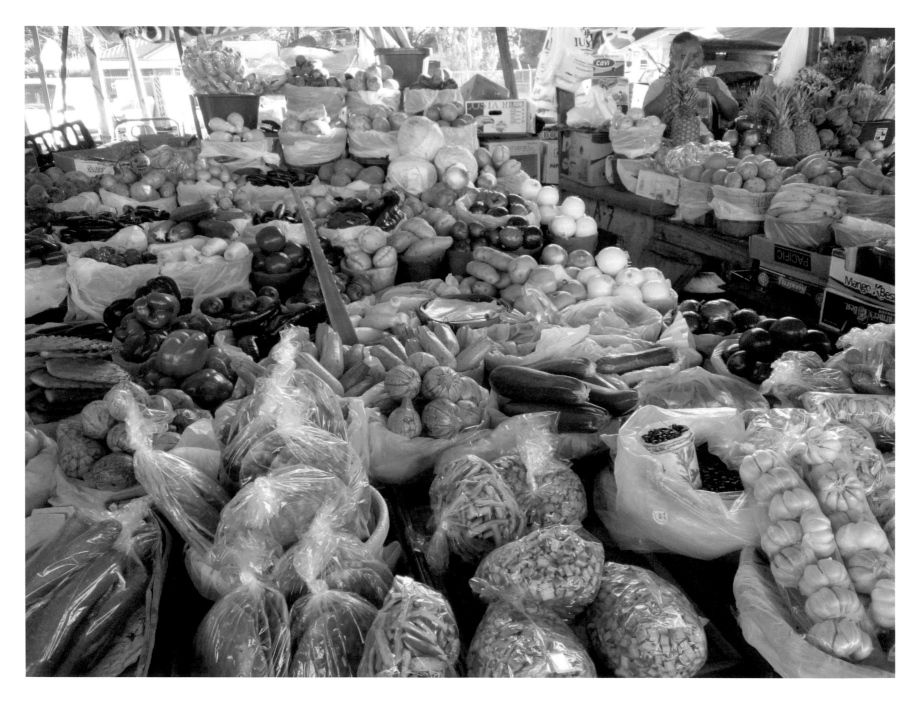

PHOTOGRAPHS BY KELLY RIVERA
Fifth Grade, Love Elementary School

Canino Airline Market

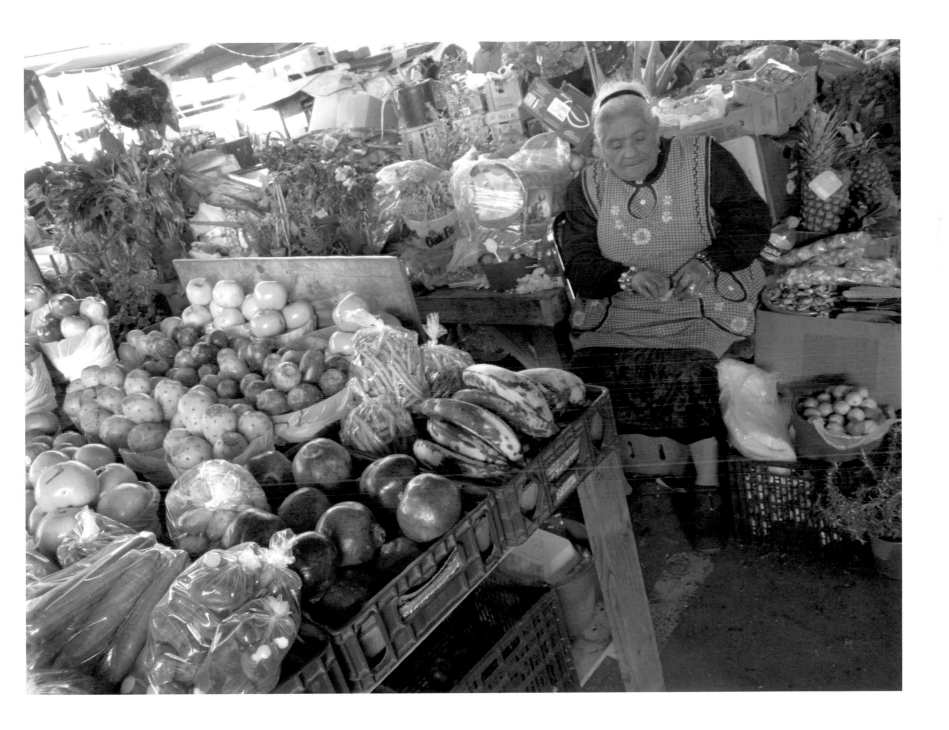

PHOTOGRAPHS BY ANNALISE ROSENBAUM
Eighth Grade, The Rusk School

Food Trucks, Telephone Road

Photograph by Alejandro Santillán
Third Grade, Love Elementary School

Food Truck, Airline Drive

PHOTOGRAPHS BY GRACIE BURNS
Fifth Grade, Mark Twain Elementary School

Hong Kong Mall

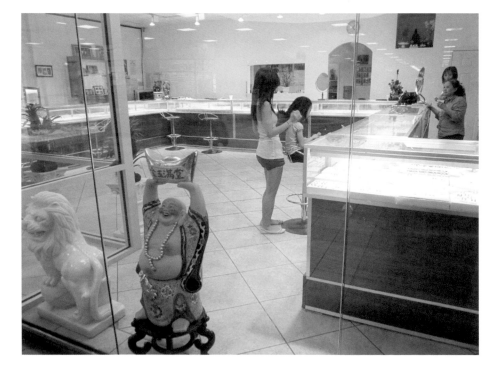

Photograph by Nina Ignatiev
Fifth Grade, Mark Twain Elementary School

Hong Kong Mall (above and lower left)

Photograph by Elias Blair
Fourth Grade, Wilson Elementary School

Hong Kong Mall (upper left)

Part V: Home Life

In addition to exploring and photographing the city of Houston, students were urged to make images of whatever they found interesting in their own homes. They photographed their parents and siblings, their rooms, toys, pets, and family gatherings. They were also urged to make self-portraits by pointing their cameras at themselves, by photographing their shadows and reflections, or by handing their camera to a friend and posing for them.

PHOTOGRAPH BY SOPHIA VU
Second Grade, Love Elementary School

My Family (above)

PHOTOGRAPH BY MICHAEL BROUSSARD
Fourth Grade, Kipp Zenith Academy

Me and My Dad (right)

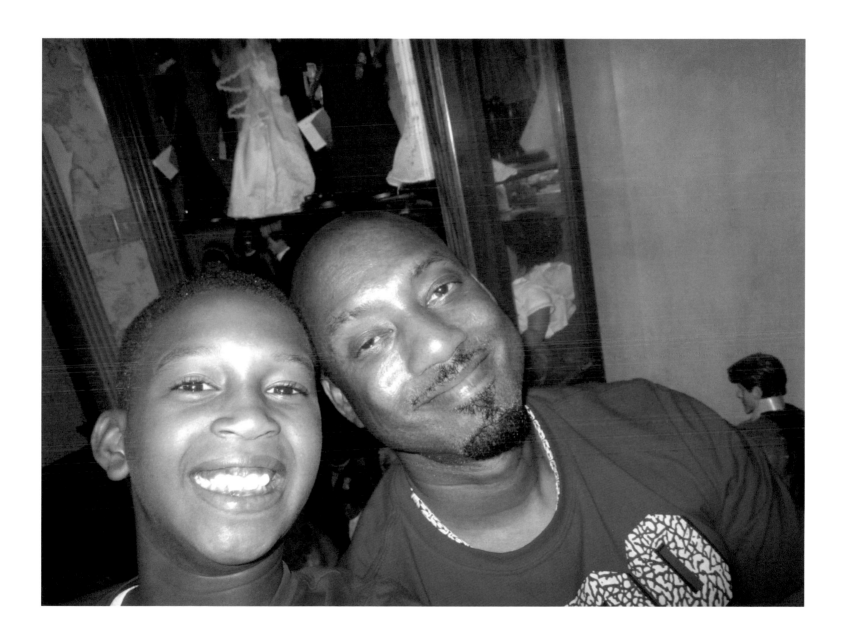

Photograph by Tristyn Bonsen
Second Grade, Love Elementary School

Party in My Room (above)

Photograph by Lysander (Xander) Van den Nieuwenhof
Second Grade, Love Elementary School

Various Vegetables and Superheroes (right)

PHOTOGRAPHS BY KAI TUBBS
Fourth Grade, Kipp Zenith Academy

Daydreaming (above)
Our Family Photos (right)

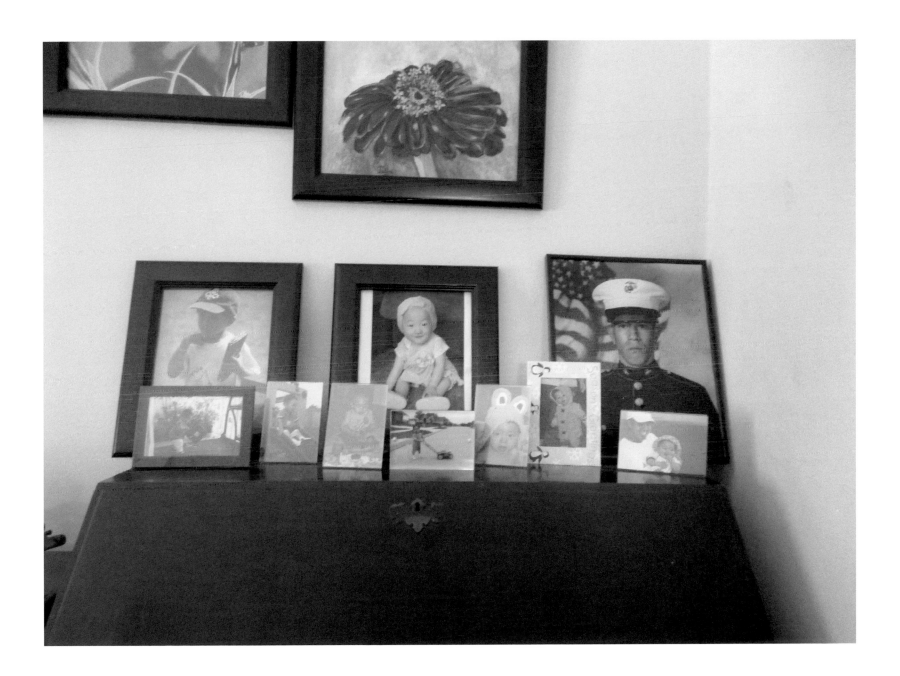

Photographs by Citlali Arzola
Third Grade, Love Elementary School

El amor de mi mama y mi papa (above)
Mi casa azul (right)

PHOTOGRAPH BY EDGAR DE JESÚS
Fourth Grade, Love Elementary School

My Room (above)

PHOTOGRAPH BY STELLA CASSILLO-BROWN
First Grade, Love Elementary School

My Room (right)

PHOTOGRAPH BY KELLY RIVERA
Fifth Grade, Love Elementary School

My Family! (above)

PHOTOGRAPH BY GABRIELA RODRÍGUEZ
Kindergarten, Treasure Forest Elementary School

Mama Making Tortillas (right)

PHOTOGRAPH BY DANIELA DÍAZ
Fourth Grade, Kipp Zenith Academy

Headstand (above)

PHOTOGRAPH BY CALLIE NICHOLS
Fifth Grade, Mark Twain Elementary School

Watching TV (right)

PHOTOGRAPH BY MELISSA RIVAS
Fourth Grade, Kipp Zenith Academy

In My Room (above)

PHOTOGRAPH BY KAI TUBBS
Fourth Grade, Kipp Zenith Academy

A Look Inside the Fridge (right)

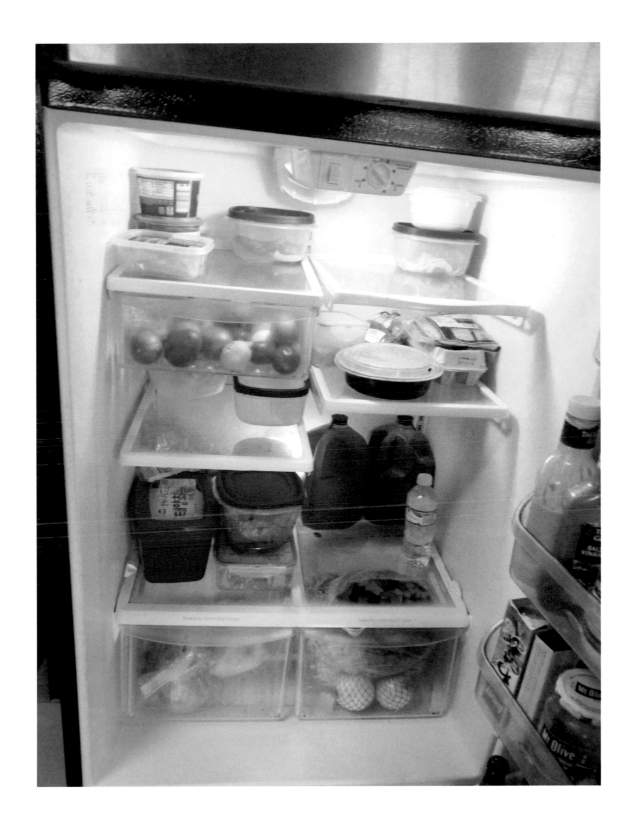

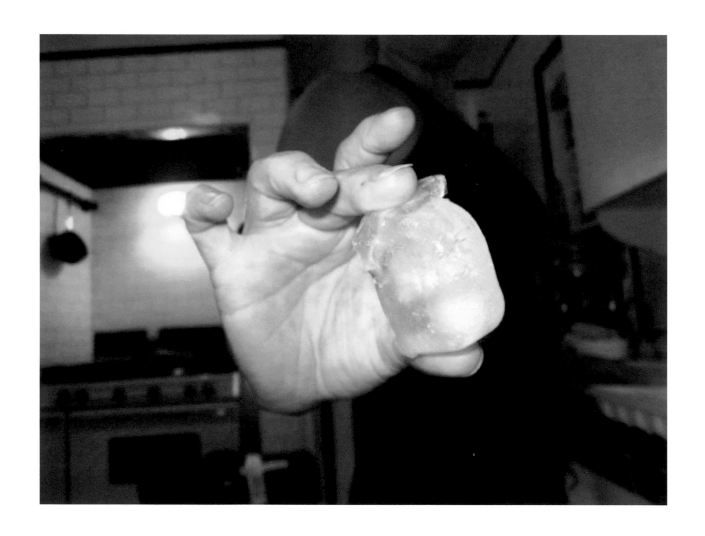

PHOTOGRAPHS BY ELLE DEVINE
Kindergarten, Love Elementary School

Ice Cube (above)

Dog Butt (right)

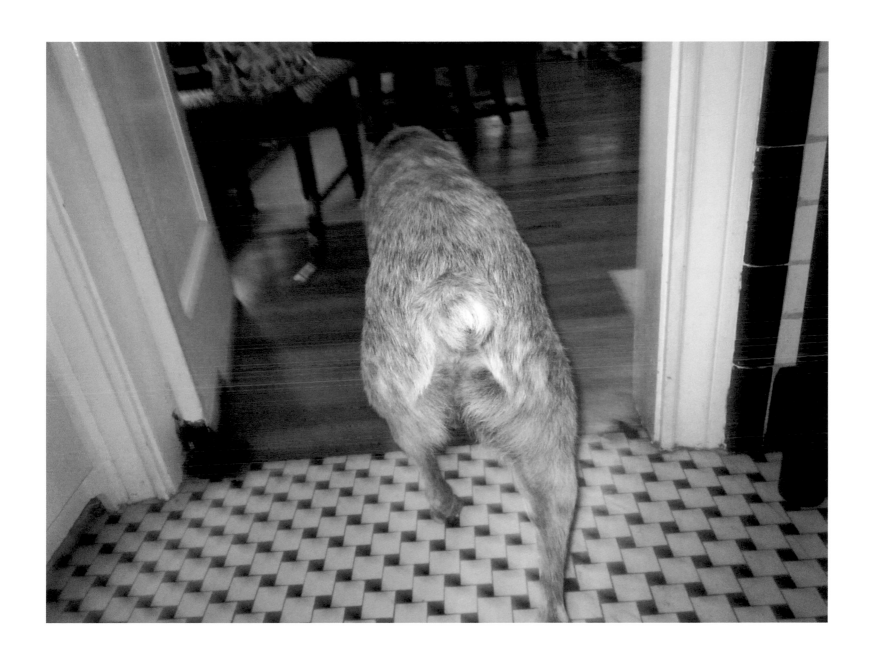

PHOTOGRAPH BY DAMIEN VILLARREAL
Fifth Grade, Love Elementary School

Sad Shadows (above)

PHOTOGRAPH BY TRISTYN BONSEN
Fourth Grade, Love Elementary School

Grampy in His Chair (right)

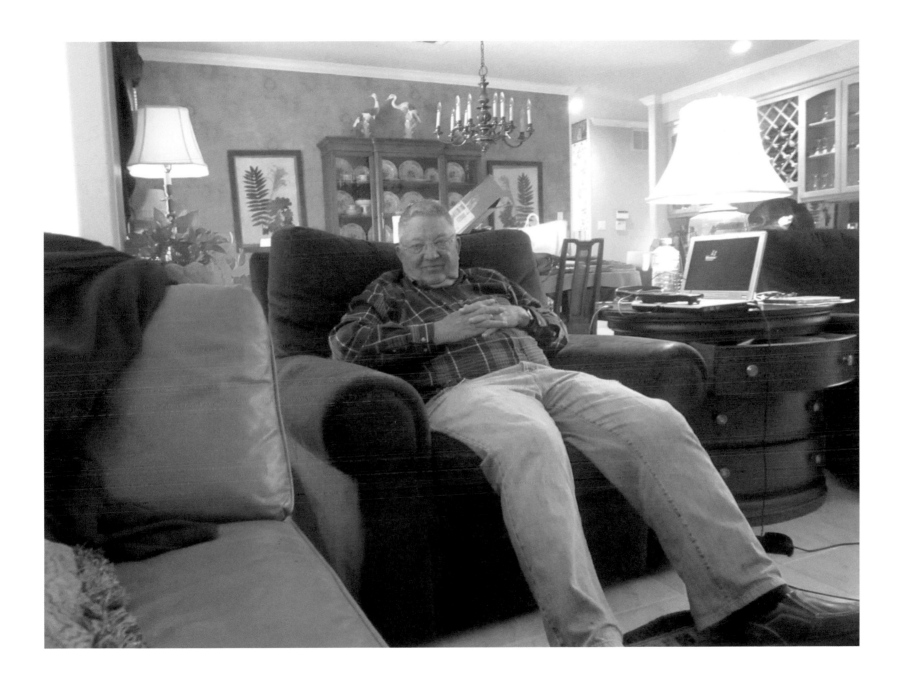

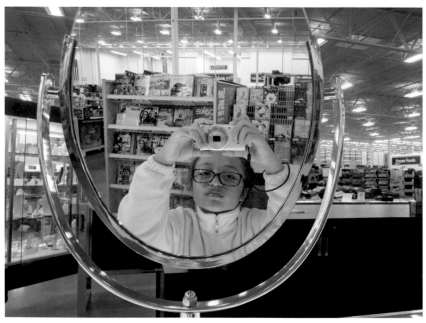

Photograph by Robel Tesfamichael
Seventh Grade, Las Americas Middle School

Self-Portrait (upper left)

Photograph by Daniela Díaz
Fourth Grade, Kipp Zenith Academy

Self-Portrait (lower left)

Photograph by Kelly Rivera
Sixth Grade, Hamilton Middle School

Self-Portrait (upper right)

Photograph by Alisson Aguirre
Eighth Grade, Lanier Middle School

Self-Portrait (lower right)

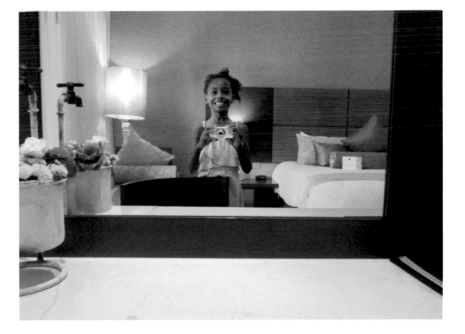

PHOTOGRAPH BY LYSANDER (XANDER) VAN DEN NIEUWENHOF
Third Grade, Love Elementary School

Self-Portrait (upper left)

PHOTOGRAPH BY JORDYN GRIFFIN
Fourth Grade, Kipp Zenith Academy

Self-Portrait (lower left)

PHOTOGRAPH BY STELLA CASSILLO-BROWN
First Grade, Love Elementary School

Self-Portrait (upper right)

PHOTOGRAPH BY MINA BROWN
Fourth Grade, Kipp Zenith Academy

Self-Portrait (lower right)

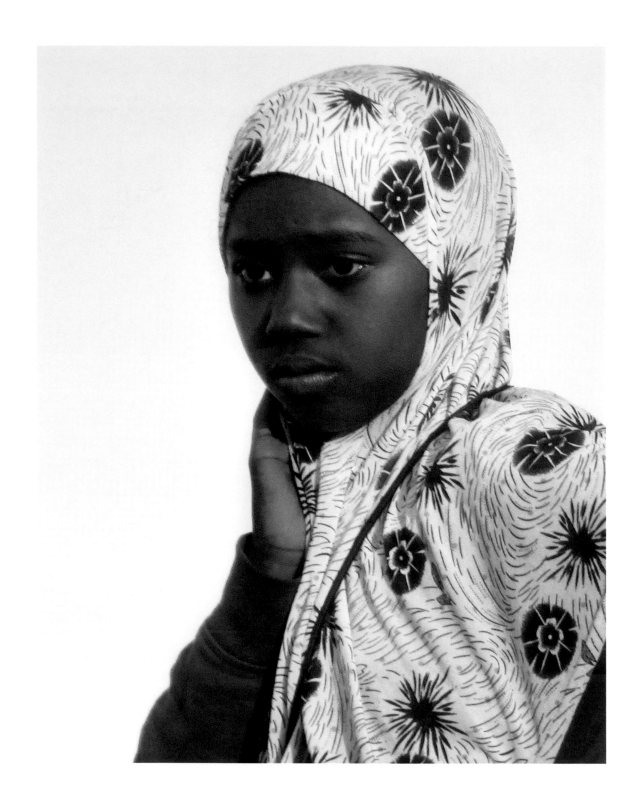

Photograph by Nyashimwe Gashangu
Seventh Grade, Las Americas Middle School

Self-Portrait (above)

Photograph by Johara Jibril
Seventh Grade, Las Americas Middle School

Self-Portrait (left)

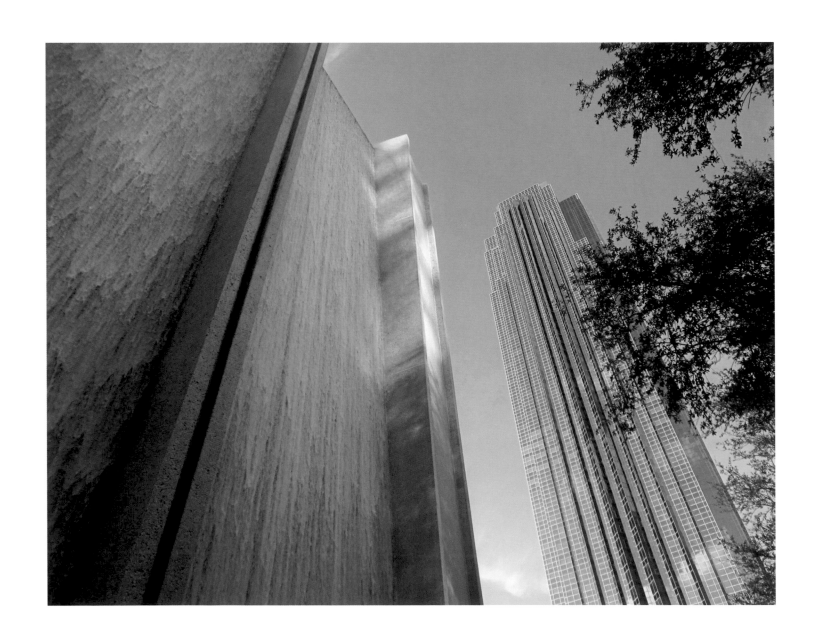

PHOTOGRAPH BY KELLY RIVERA
Fifth Grade, Love Elementary School

The Water Wall and the Williams Tower

PART VI: MONUMENTS, PARKS, MUSEUMS, AND EVENTS

A great tower of glass and steel, mirroring the sky.
An urban waterfall of rushing water, set in arches of white stone.
Parks with monuments to historic battles and heroes.
A zen garden.
An outdoor theater for evening concerts.
Museums presenting art collections from antiquity to the present day.
A planetarium.
A zoological garden.
The rocket that once transported men from earth to the moon.
A park dedicated to the power and purity of the orange fruit.
The world's largest rodeo.
Automobiles reimagined as art, parading on the city streets.
Ball games played in colossal stadiums.
Ceremonial dances marking the turn of the calendar year.
A refuge for butterflies.

All this—all this and much more—is the city, the essence of our civilization.

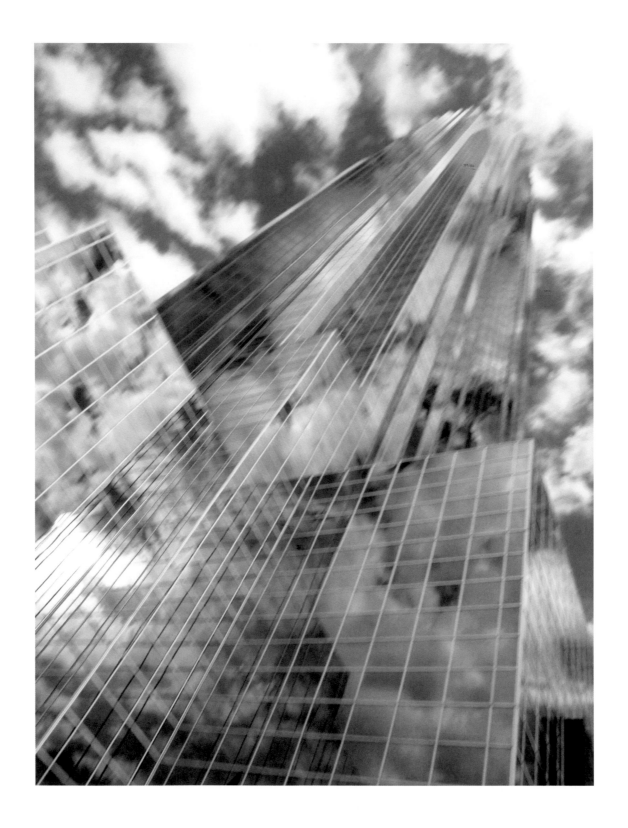

PHOTOGRAPH BY GABRIELA KOMINEK
Fourth Grade, Love Elementary School

The Water Wall (above)

PHOTOGRAPH BY JOTI BHUJEL
Seventh Grade, Las Americas Middle School

The Williams Tower (left)

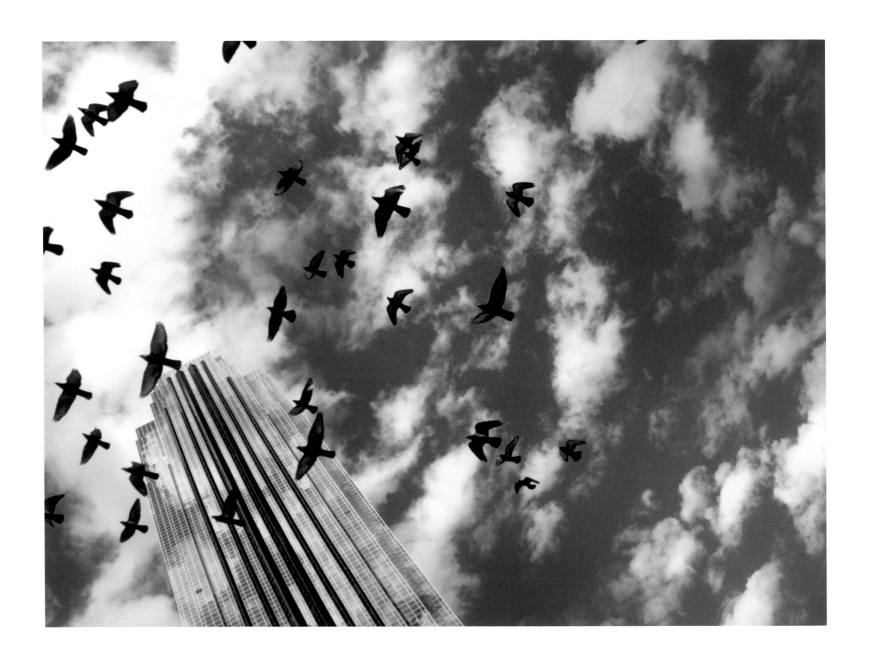

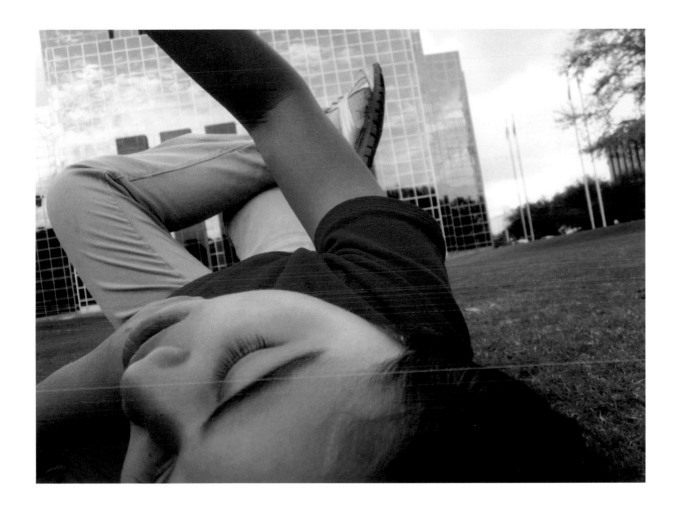

PHOTOGRAPH BY GABRIELA KOMINEK
Fourth Grade, Love Elementary School

Kelly under the Tower (above)

PHOTOGRAPH BY ROBEL TESFAMICHAEL
Seventh Grade, Las Americas Middle School

The Tower and the Birds (left)

PHOTOGRAPH BY ZACHARIAH WROBEL
Third Grade, Love Elementary School

Path along the Bayou (above)

PHOTOGRAPH BY TERRANCE (T. J.) WASHINGTON
KINDERGARTEN, *Love Elementary School*

Watery Reflections (right)

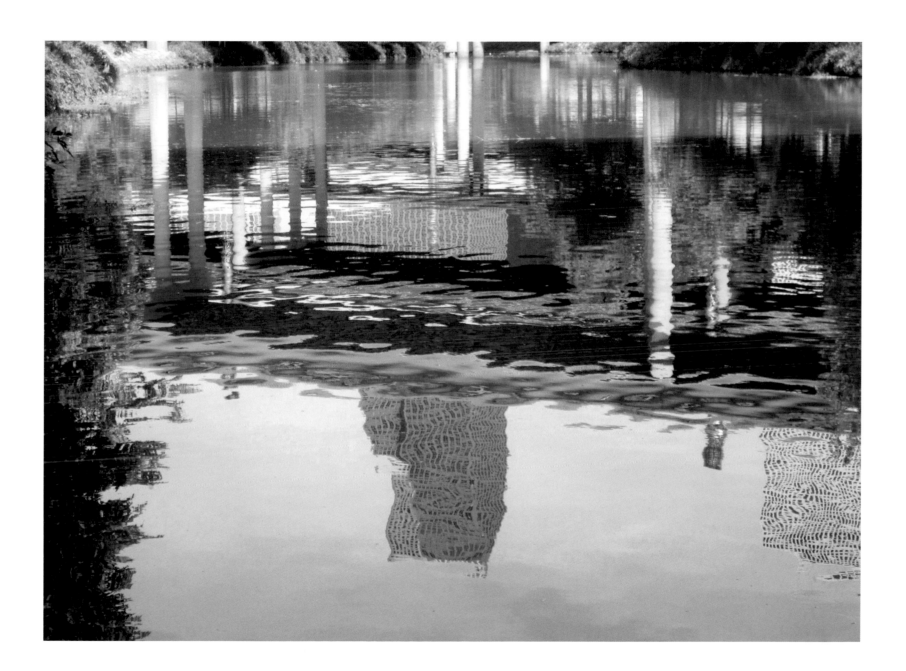

Photograph by Annalise Rosenbaum
Eighth Grade, The Rusk School

Buffalo Bayou Park (above)

Photograph by Elena Alcalá
Fifth Grade, Love Elementary School

Buffalo Bayou Park (left)

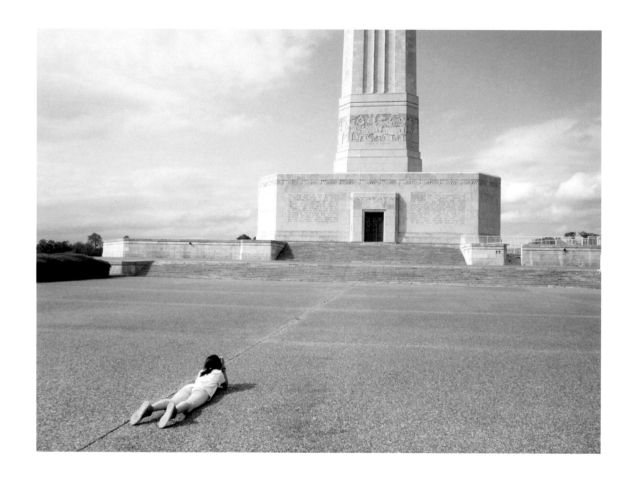

ALANIS CASTAÑO PHOTOGRAPHING AT THE SAN JACINTO MONUMENT *(above)*

PHOTOGRAPH BY ALANIS CASTAÑO
Eighth Grade, Lanier Middle School

San Jacinto Monument (right)

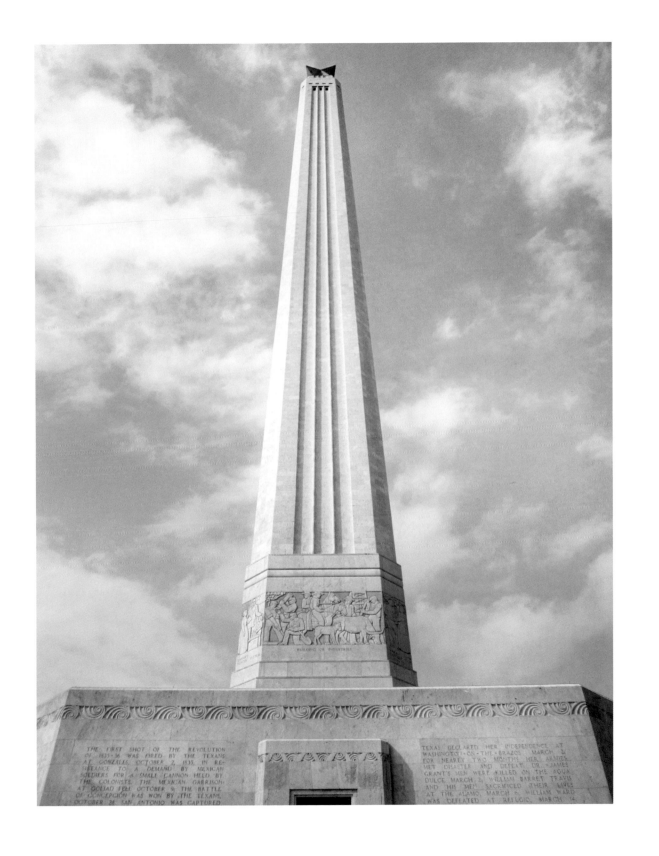

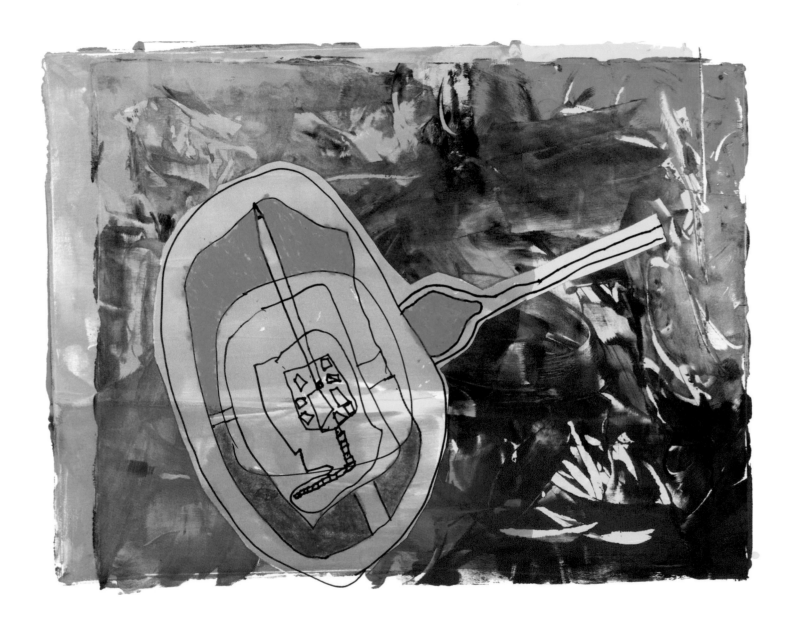

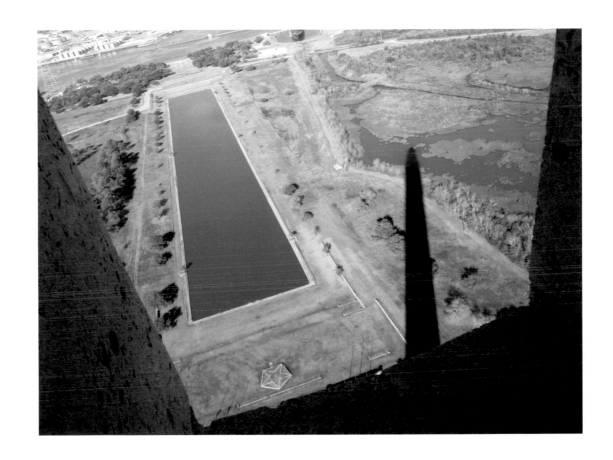

PHOTOGRAPH BY IMNET PETRO
Seventh Grade, Las Americas Middle School

The Shadow of the Monument (above)

MONOPRINT WITH MARKERS BY DOMINICK REYES
First Grade, Love Elementary School

San Jacinto Monument, Aerial View (left)

PHOTOGRAPH BY AKEK BLAIR
Fourth Grade, Wilson Montessori School

Rice University Campus (above)

PHOTOGRAPH BY ALICIA MELÉNDEZ
Fourth Grade, Wilson Montessori School

Rice University Campus and the Texas Medical Center (right)

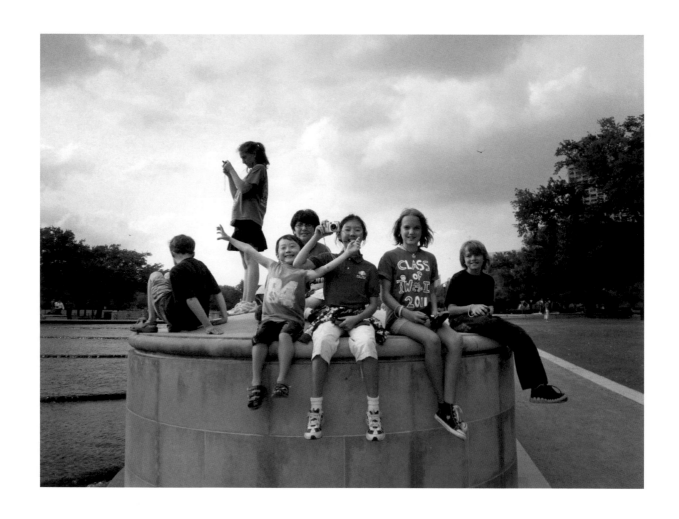

MARK TWAIN ELEMENTARY SCHOOL STUDENTS AT HERMANN PARK *(above)*

PHOTOGRAPH BY HOLLAND VAN DEN NIEUWENHOF
Fourth Grade, Love Elementary School

Kite Day in Hermann Park (right)

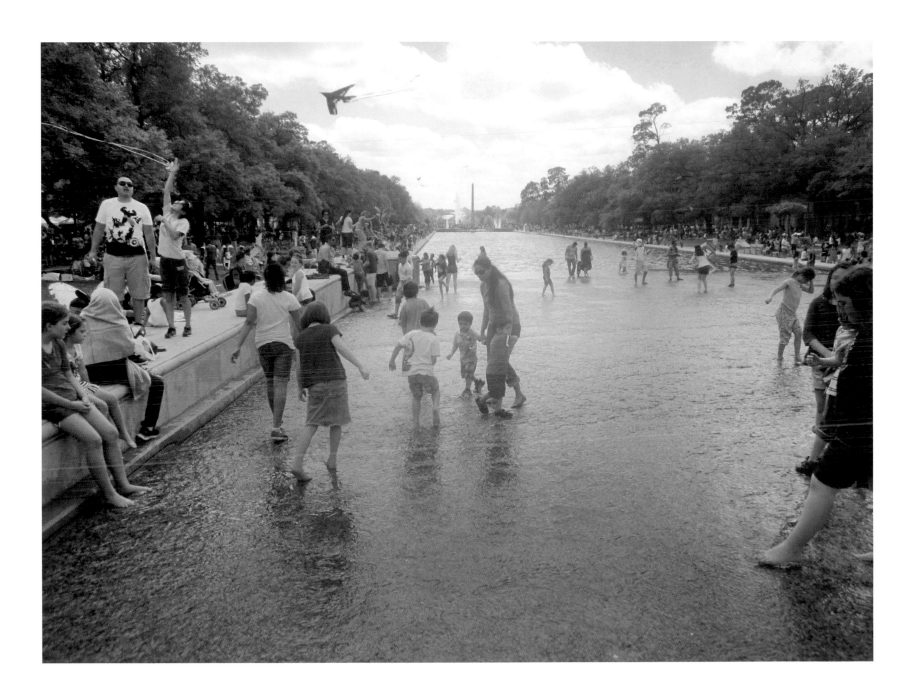

Hermann Park, 445 acres in the heart of Houston, was given to the city by George Hermann in 1914. Today it is home to several major cultural institutions, including the the Japanese Garden, Houston Zoo, McGovern Centennial Gardens, Miller Outdoor Theatre, and the Houston Museum of Natural Science. Six million people a year visit the park.

The Japanese Garden, designed by world-renowned Japanese landscape architect Ken Nakajima, is based on a 17th century Japanese stroll garden.

The Houston Zoo houses over 6,000 animals of 900 different species and receives 1.8 million visitors each year. The McGovern Centennial Gardens, a recent addition to the park, is comprised of a diverse collection of gardens and features a 30-foot, spiral grassy knoll, from which visitors have a dramatic view of the surrounding park.

Miller Outdoor Theatre, sitting on a hilltop in Hermann Park, offers a diverse range of professional entertainment free of charge to the public. Houstonians and visitors fill the fixed seating and cover the grassy hilltop for evening performances of classical music, jazz, ballet, Shakespeare, musical theater, and concert artists.

Photograph by Sierra Ondo
Fourth Grade, Mark Twain Elementary School

The Japanese Garden, Hermann Park

PHOTOGRAPH BY GRACIE BURNS
Fifth Grade, Mark Twain Elementary School

The Japanese Garden, Hermann Park (above)

PHOTOGRAPH BY RACHAEL LEE
Ffith Grade, Mark Twain Elementary School

The Japanese Garden, Hermann Park (right)

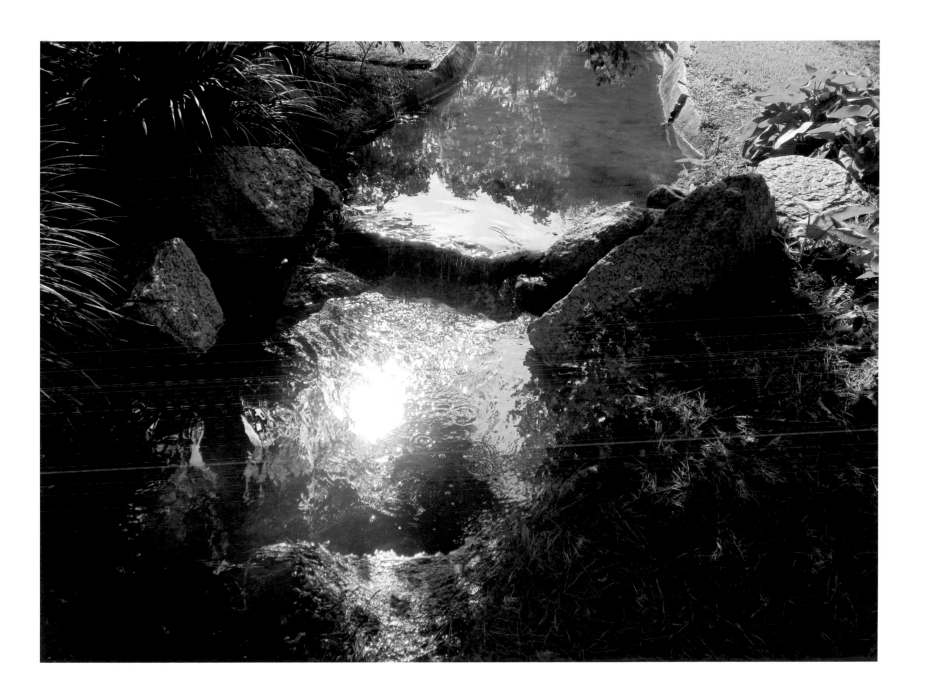

PHOTOGRAPH BY KELLY RIVERA
Sixth Grade, Hamilton Middle School

The Japanese Garden, Hermann Park (above)

PHOTOGRAPHS BY SIERRA ONDO
Fourth Grade, Mark Twain Elementary School

The Japanese Garden, Hermann Park (right)

Monoprint with color pencil, markers, and pastel
by Joel Montealvo
Third Grade, Love Elementary School

The Houston Zoo

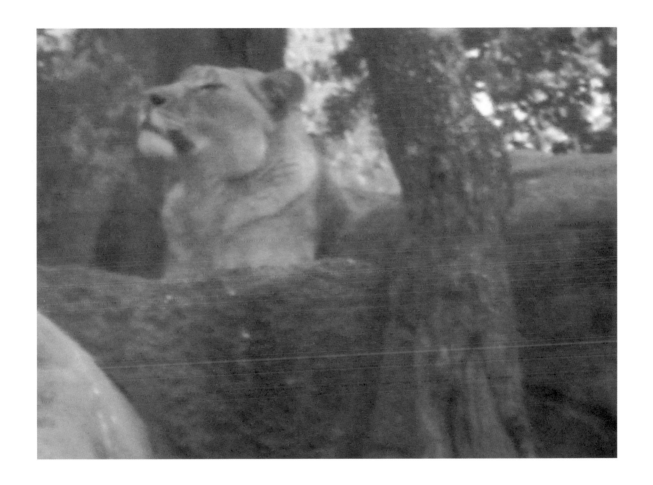

Photograph by Estephania Espinoza
Fifth Grade, Love Elementary School

The Lion at Rest

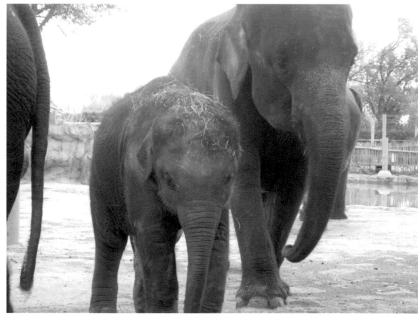

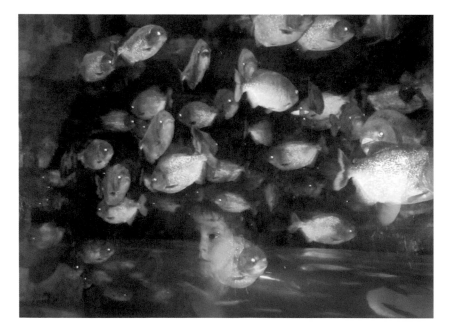

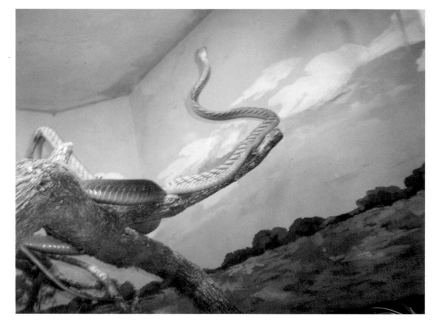

PHOTOGRAPH BY LEXI BALDWIN
Fourth Grade, Love Elementary School
The Houston Zoo (upper left)

PHOTOGRAPH BY ESTEPHANIA ESPINOZA
Fifth Grade, Love Elementary School
The Houston Zoo (lower left)

PHOTOGRAPH BY LEXI BALDWIN
Fourth Grade, Love Elementary School
The Houston Zoo (upper right)

PHOTOGRAPH BY AKIRA BONSEN
Kindergarten, Love Elementary School
The Houston Zoo (lower right)

186

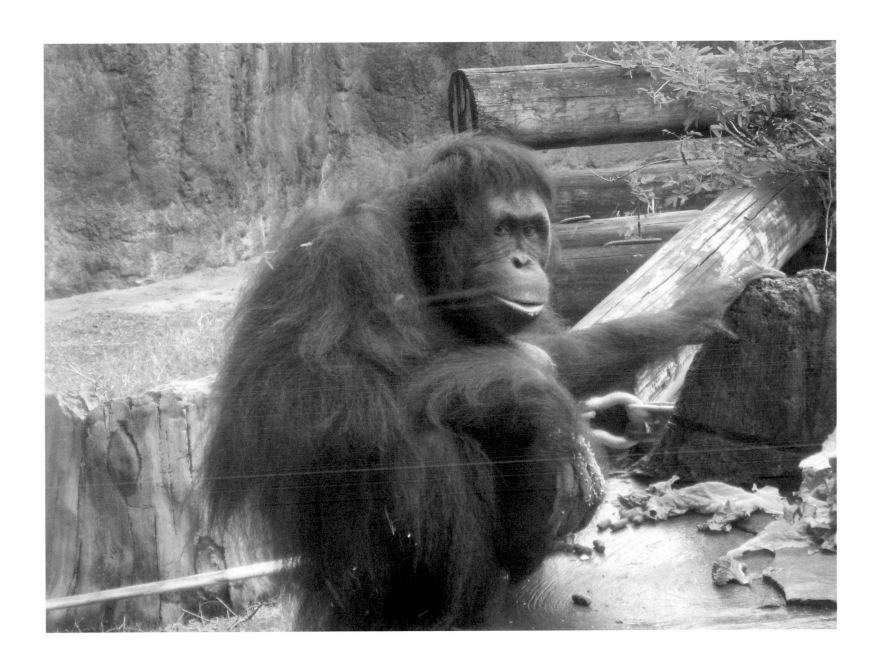

PHOTOGRAPH BY MAURICIO RIVERA
Third Grade, Love Elementary School

The Houston Zoo

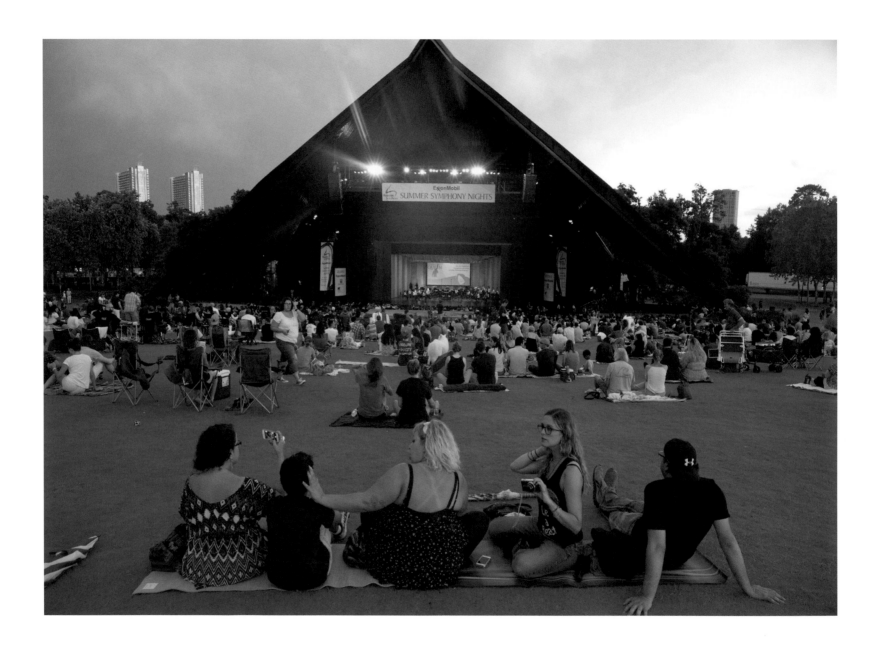

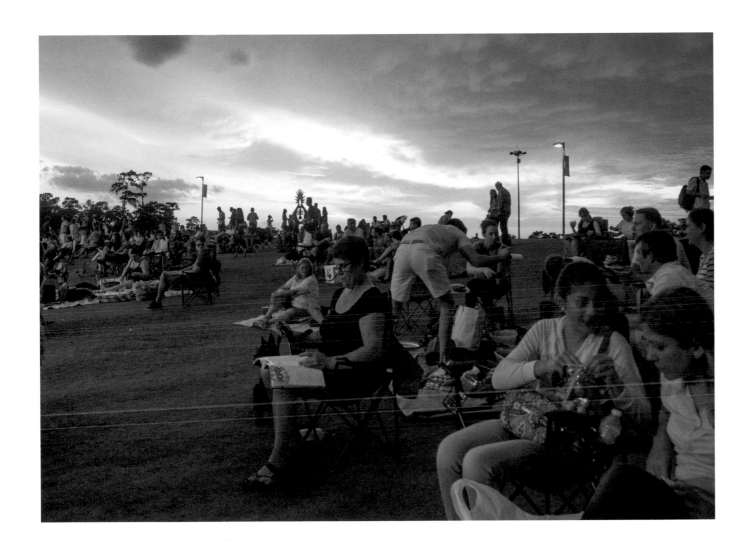

Photographs by Alicia Meléndez
Fifth Grade, Wilson Montessori School

Summer Symphony Performance at Miller Outdoor Theatre

At 4:18 p.m. on July 20, 1969, Astronaut Neil Armstrong's voice crackled from the speakers at NASA's Mission Control, "Houston, Tranquillity Base here. The Eagle has landed." With those words, the dream that President John F. Kennedy had voiced in 1961—putting humans on the moon by the end of the decade—had come true.

Since that moment, Houston has been known around the world as "Space City." Over a million people visit Space Center Houston each year, where the big attractions include an actual Saturn rocket booster (36 stories tall), a Lunar Landing Module, and the historic Mission Control Room.

Monoprint with color pencil, markers, and pastel
by Alek Blair
Fourth Grade, Wilson Montessori School

Portrait of Neil Armstrong

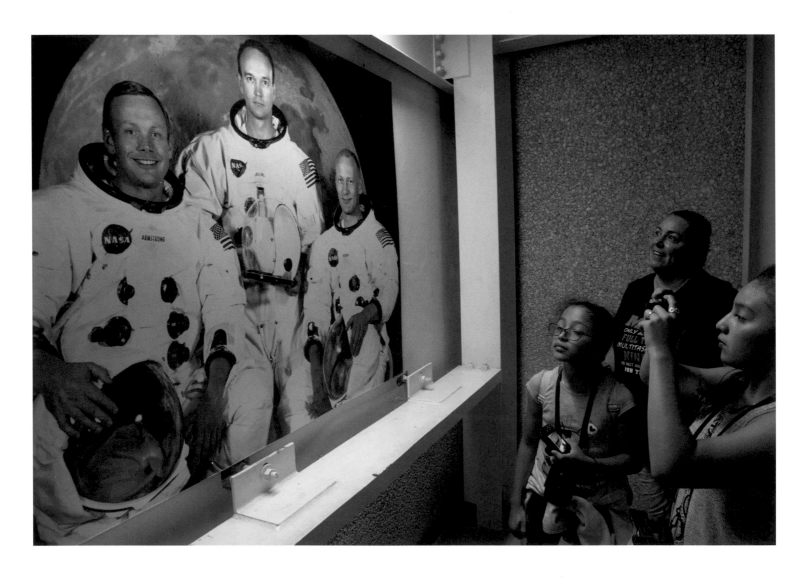

STUDENTS PHOTOGRAPHING AT SPACE CENTER HOUSTON *(above)*

PHOTOGRAPH BY ABIGAIL OYERVIDEZ
Fourth Grade, Wilson Montessori School

Space Center Houston, Rockets Display (upper right)

PHOTOGRAPH BY ELLE DEVINE
Fifth Grade, Crockett Middle School

Space Center Houston, Moon Rover Display (lower right)

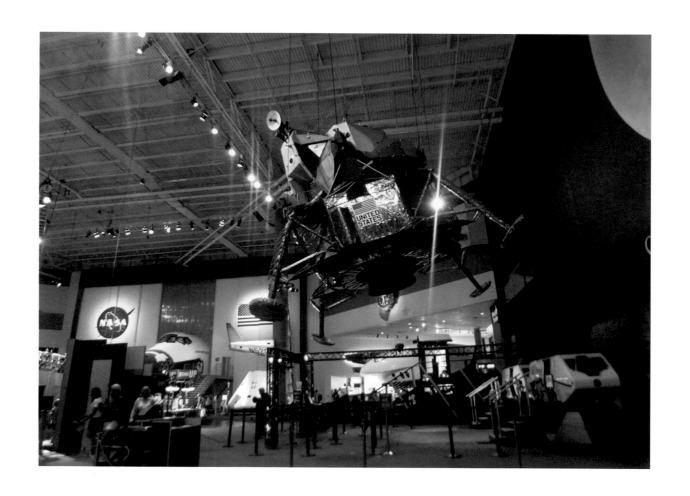

PHOTOGRAPH BY ALICIA MELÉNDEZ
Fourth Grade, Wilson Montessori School

Lunar Landing Module, Space Center Houston (above)

PHOTOGRAPH BY REBECCA WOLFARTH
Fourth Grade, Wilson Montessori School

Original Mission Contral Center, Space Center Houston (right)

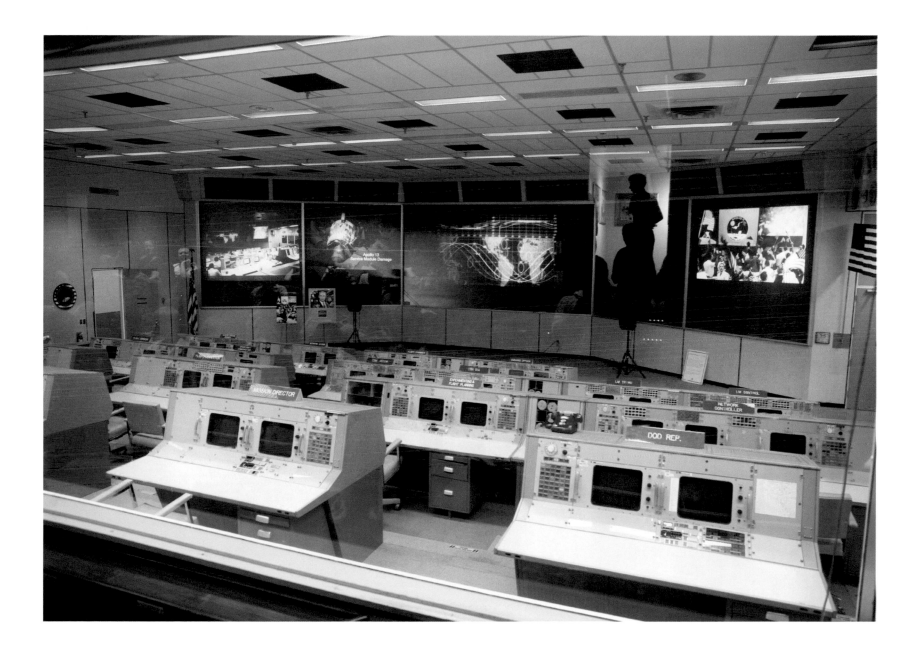

Houston has emerged as a major center for the creation and exhibition of visual art, and its extraordinary range of museums and art galleries has become a major attraction for visitors from around the world. In all, an estimated 57 museums are open to the public across the greater Houston area.

The Museum of Fine Arts, Houston, is the anchor of the city's visual art world. Founded in 1900, it has grown to be the largest cultural institution in the southwest United States. Its permanent collection includes 65,000 objects of art dating from antiquity to the present, with in-depth holdings of American art, European paintings, decorative arts and design, photography, modern and contemporary painting and sculpture, and Latin American art.

The city's Museum District includes 18 additional museums. The Contemporary Arts Museum, sitting diagonally across from the MFAH, founded in 1948, has been a major force in the development of the city's vibrant contemporary art scene. The Menil Collection—with approximately 17,000 paintings, sculptures, prints, drawings, photographs, and rare books—is one of the largest and most wide-ranging private art collections in the United States. The Houston Museum of Natural Science, on the northwestern corner of Hermann Park, was established in 1909. Today, with four floors of natural science halls and exhibits, the Burke Baker Planetarium, the Cockrell Butterfly Center, and the Wortham Giant Screen Theatre, the museum's annual attendance totals over two million visitors.

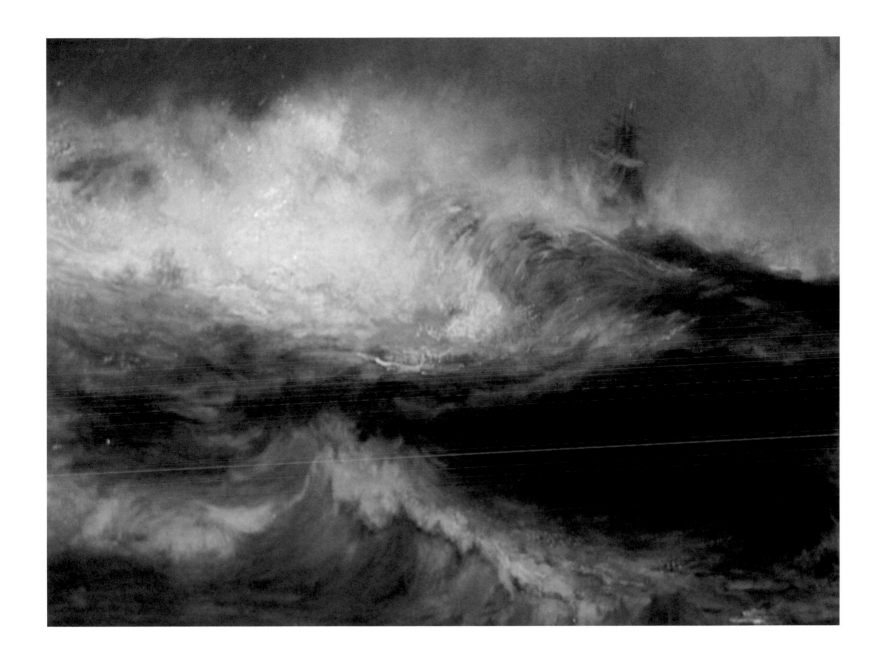

PHOTOGRAPH BY KYOTO BERHANE-NEFF
Fifth Grade, Mark Twain Elementary School

Detail from Stranded Ship on East Hampton Bay *by Thomas Moran*
 in the Museum os Fine Arts, Houston

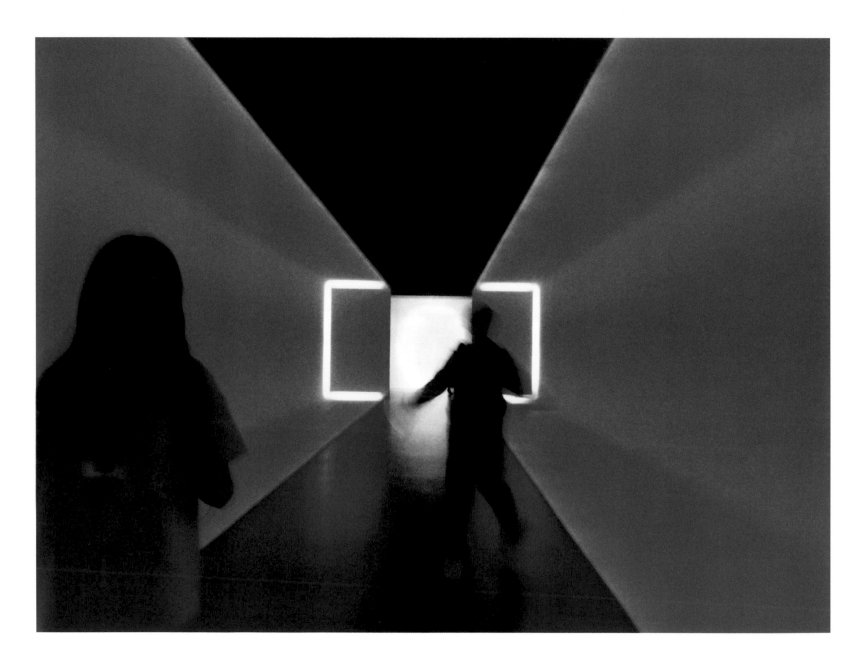

PHOTOGRAPH BY CAROLINE ANTHONY *(above)*
Fourth Grade, Mark Twain Elementary School

Inside The Light Inside *by James Turrell,*
in the Museum of Fine Arts, Houston

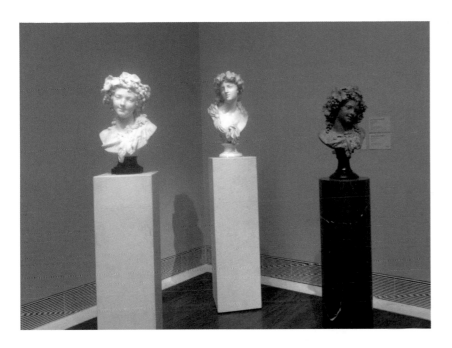

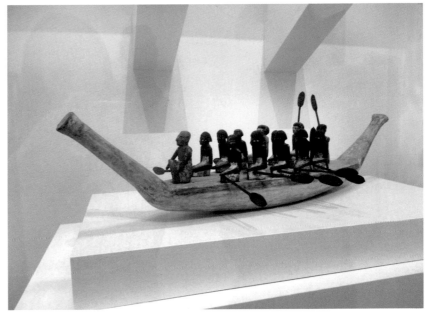

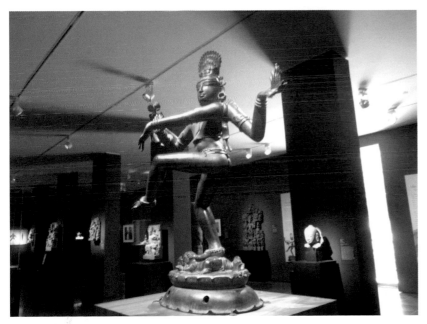

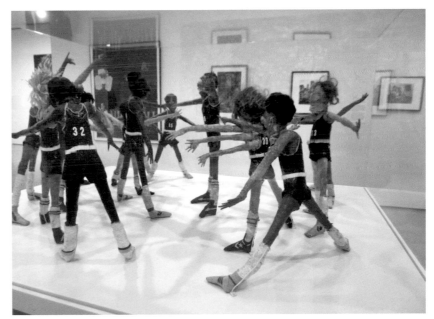

PHOTOGRAPHS BY MAKENNA LEE
Fifth Grade, Mark Twain Elementary School

Three Busts of Bacchante by Albert-Ernest Carrier Bellense (upper left)
Egyptian Model Boat (upper right)
Shiva Nataraja (lower left)
in the Museum of Fine Arts, Houston

PHOTOGRAPH BY SCOUT SUSTALA
Seventh Grade, Pershing Middle School

Basketball Players *by Jesse Lott (lower right)*
in the Museum of Fine Arts, Houston

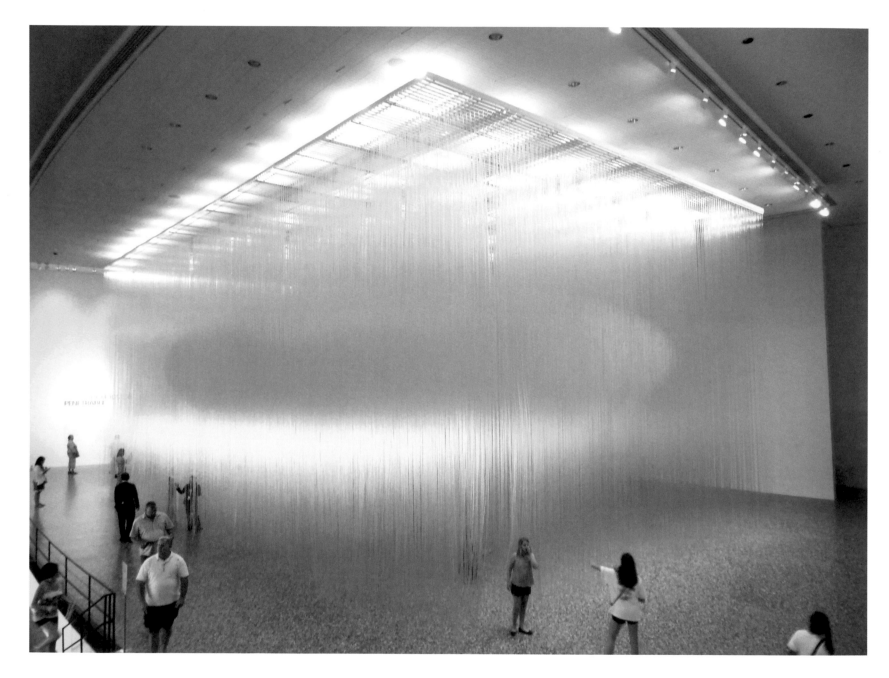

PHOTOGRAPH BY SOPHIA VU
Fifth Grade, Love Elementary School

Houston Penetrable *by Jesús Raphael Soto*
in the Museum of Fine Arts, Houston

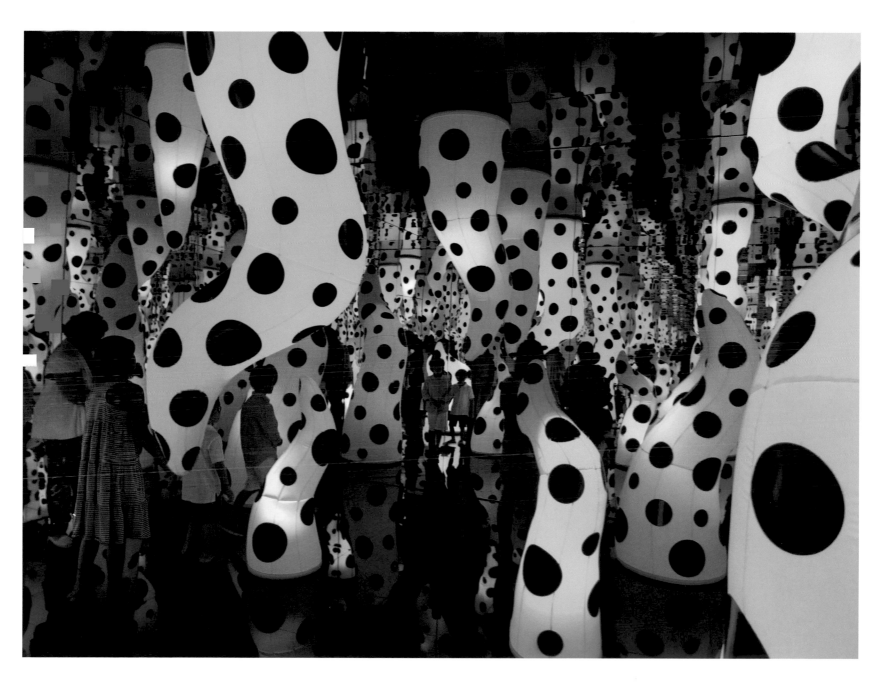

PHOTOGRAPH BY DARIO AVILÁ
Sixth Grade, Hogg Middle School

Kusama: At the End of the Universe *by Yayoi Kusama*
in the Museum of Fine Arts, Houston

PHOTOGRAPHS BY DOMINICK REYES
First Grade, Love Elementary School

Archaeic Head VI *by Roy Lichtenstein in the Museum of Fine Arts, Houston (above)*
From the Sculpted in Steel *Exhibition at the Museum of Fine Arts, Houston (right)*

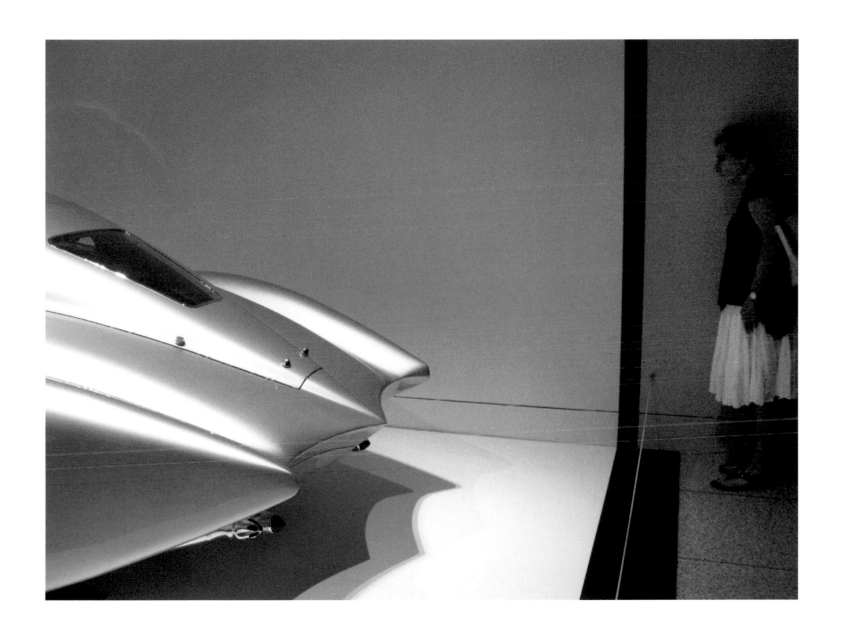

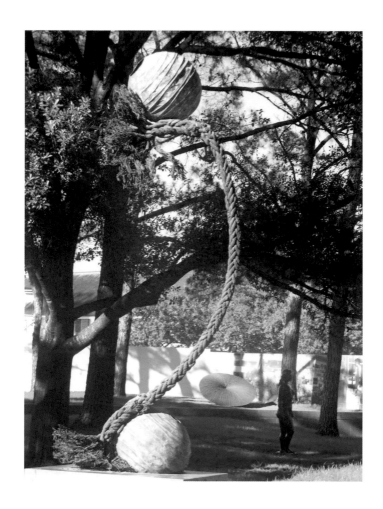

PHOTOGRAPHS BY JORDYN GRIFFIN
Fourth Grade, Kipp Zenith Academy

Hollow, *by Clare Webb (above)*
Poke, *by Finell (right)*
Contemporary Arts Museum, Houston

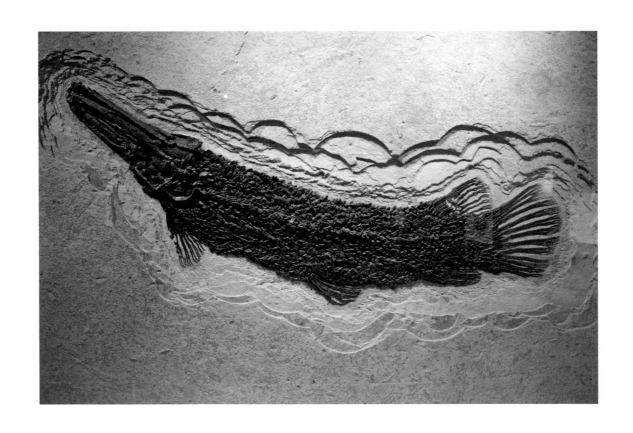

PHOTOGRAPH BY ESTEPHANIA ESPINOZA
Sixth Grade, Lanier Middle School

Fossil of an Alligator Gar, Museum of Natural Science (above)

PHOTOGRAPH BY GEORGIE RAWSON
Fourth Grade, Mark Twain Elementary School

Dinosaur Exhibit, Museum of Natural Science (right)

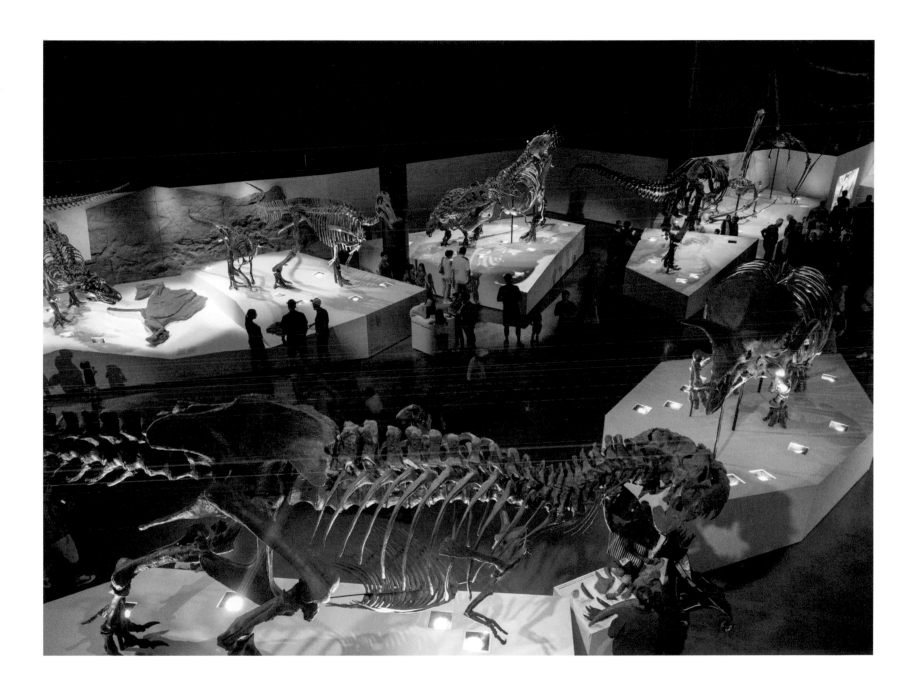

PHOTOGRAPH BY ANNA BREMAUNTZ
Sixth Grade, Lanier Middle School
Burke Baker Planetarium Show (above)

PHOTOGRAPH BY HARPER GILBERT
Fifth Grade, Wilson Montessori School

Burke Baker Planetarium Show (left)

PHOTOGRAPH BY ALEJANDRO SANTILLÁN
Third Grade, Love Elementary School

Cockrell Butterfly Center, Museum of Natural Science (above)

PHOTOGRAPH BY HARPER GILBERT
Fifth Grade, Wilson Montessori School

Cockrell Butterfly Center, Museum of Natural Science (right)

Houston's Livestock Show and Rodeo began in 1932 as the Houston Fat Stock Show. It has become the one of the city's signature event, often compared to the Texas State Fair in Dallas and Mardi Gras in New Orleans. Unfolding over three weeks in March, the show now draws over 2,500,000 people each year.

Celebrations begin when thousands of trailriders arrive—by horseback, on wagons, and by stagecoach—from across the state. After camping overnight in Memorial Park, they line up the next morning for the annual Rodeo Parade through downtown.

The rodeo itself, featuring traditional events like bull riding, saddle bronc riding, steer roping, calf roping, and barrel racing, attracts the best cowboys in the world. The rodeo concert has featured the world's biggest recording artists, including Elvis Presley, Beyoncé, Bob Dylan, Selena, and Willie Nelson. The livestock show, the largest in the world, includes breeding competitions and auctions, horse and donkey shows, and a spectacular carnival midway.

Monoprint with color pencil, markers, and pastel
by Silvia Méndez
Fourth Grade, Love Elementary School

Houston Rodeo

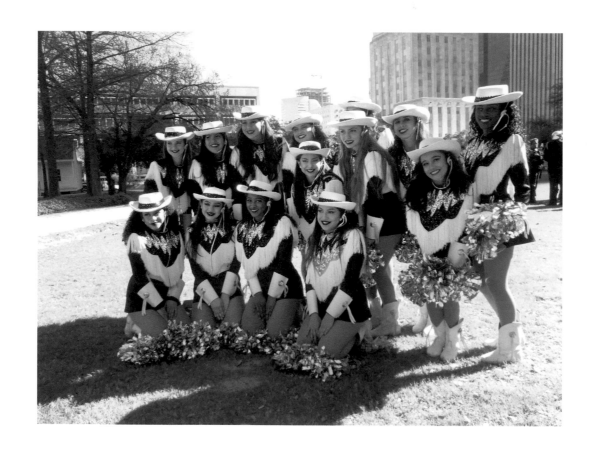

PHOTOGRAPH BY SOPHIA VU
Fifth Grade, Love Elementary School

Before the Rodeo Parade (above)

PHOTOGRAPH BY ANGEL MENA
Fifth Grade, Love Elementary School

Before the Rodeo Parade (right)

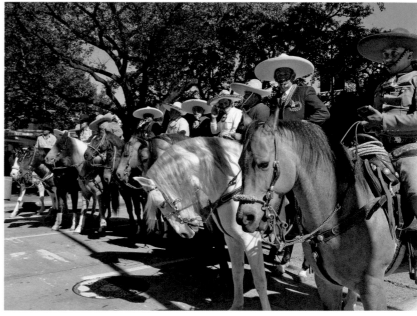

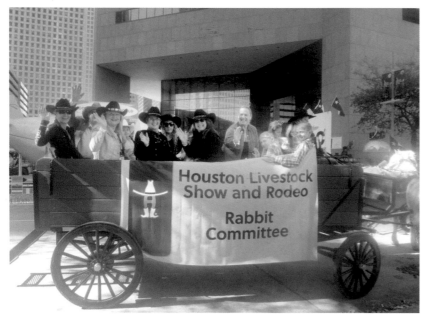

PHOTOGRAPH BY SOPHIA VU
Fifth Grade, Love Elementary School

Rodeo Parade (upper left)

PHOTOGRAPH BY ANGEL MENA
Fifth Grade, Love Elementary School

Rodeo Parade (lower left)

PHOTOGRAPH BY ANGEL MENA
Fifth Grade, Love Elementary School

Rodeo Parade (upper right)

PHOTOGRAPH BY ESTÉFANI MENDOZA
Fourth Grade, Love Elementary School

Rodeo Parade (lower right)

PHOTOGRAPH BY ESTÉFANI MENDOZA
Fourth Grade, Love Elementary School

Rodeo Parade

Photographs by Angelina Cervantes
Seventh Grade, Hamilton Middle School

Rodeo Carnival Pizzeria

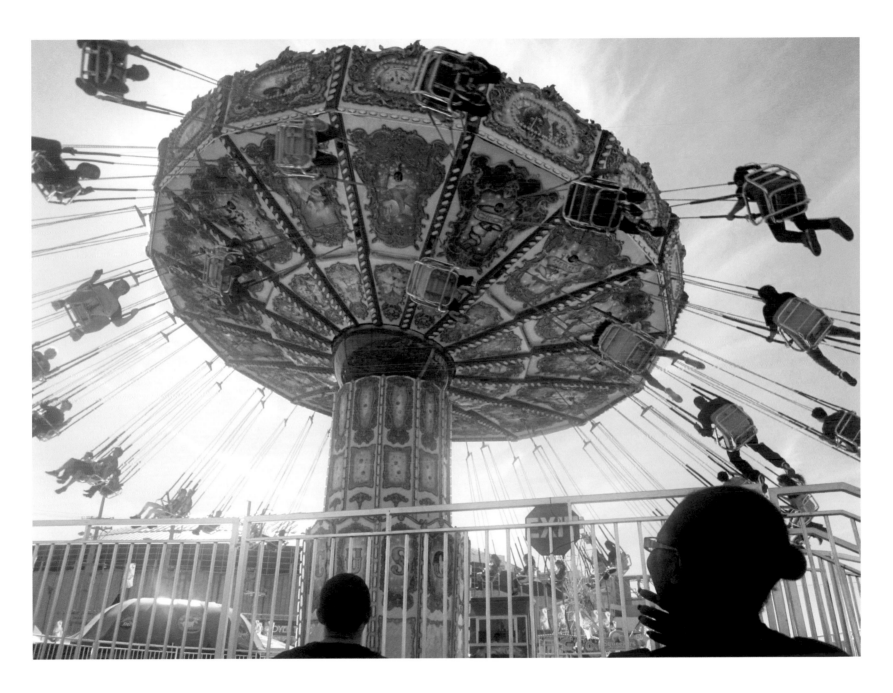

PHOTOGRAPHS BY LYSANDER (XANDER) VAN DEN NIEUWENHOF
Third Grade, Love Elementary School

Rodeo Carnival Ride

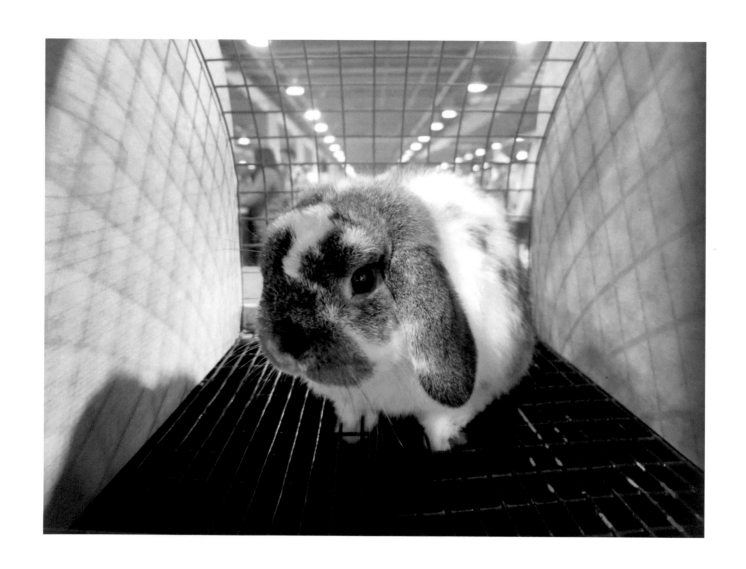

PHOTOGRAPHS BY ANGELINA CERVANTES
Seventh Grade, Hamilton Middle School

Rabbit Contestant, Livestock Show (above)

Bungee Jumping, Rodeo Carnival (right)

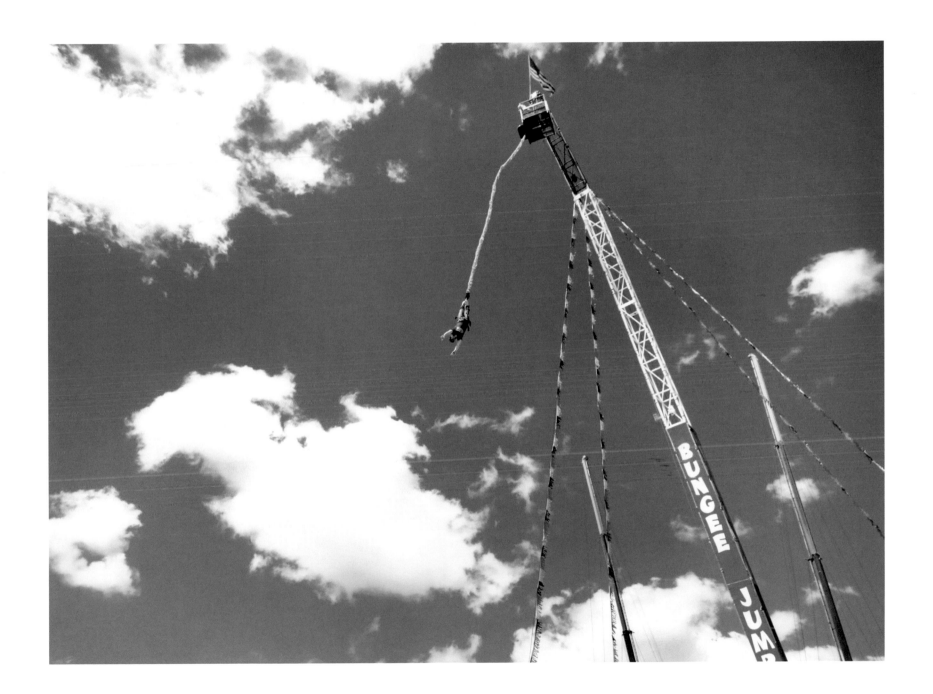

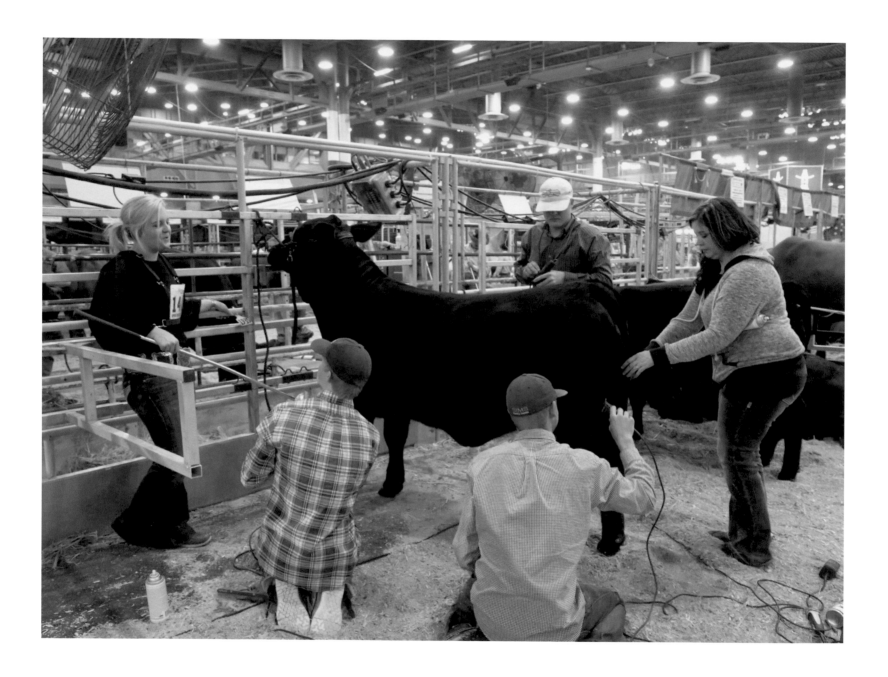

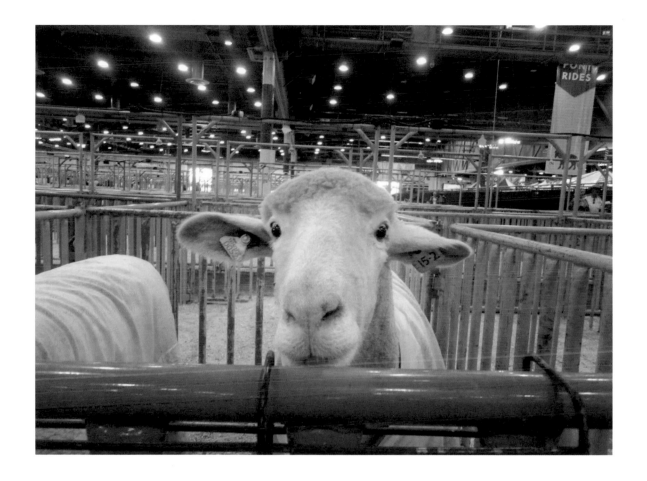

PHOTOGRAPH BY EDGAR DE JESÚS
Fourth Grade, Love Elementary School

Houston Livestock Show (above)

PHOTOGRAPH BY CITLALI ARZOLA
Eighth Grade, Hamilton Middle School

Houston Livestock Show (left)

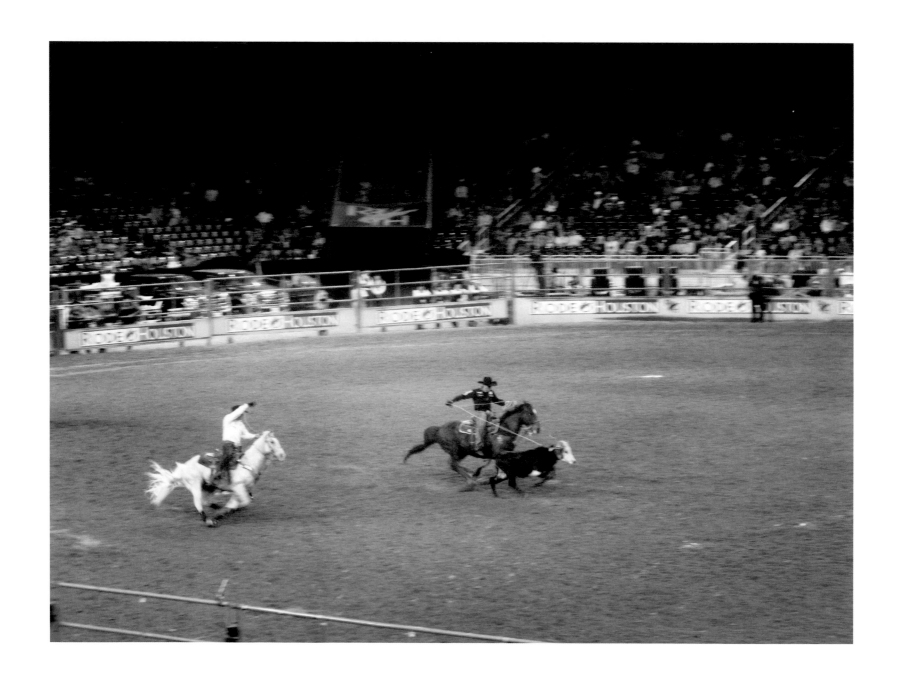

Photograph by Tristyn Bonsen
Fourth Grade, Love Elementary School

Calf Roping, Houston Rodeo

PHOTOGRAPHS BY AKIRA BONSEN
Kindergarten, Love Elementary School

Rodeo Concert

PHOTOGRAPHS BY GEORGIE RAWSON
Fourth Grade, Mark Twain Elementary School

Waiting for the Carnival Parade (above)

Houston Carnival Parade (right)

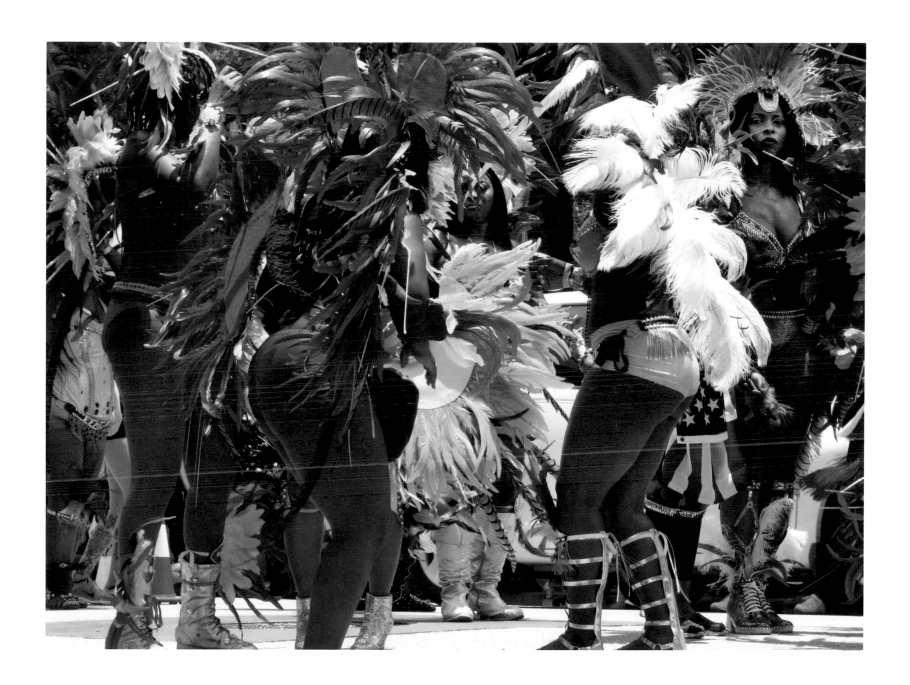

The Art Car movement began in 1984, when a 1967 Ford station wagon was sold at a Houston benefit auction. With a budget of $800 for paint and plastic fruit, artist Jackie Harris transformed the car into a mobile work of art. Her "Fruitmobile" was an artistic sensation that inspired a surge of "art cars" on the streets of Houston.

The Art Car Parade was born in April 1988 with a 40-car parade seen by an estimated 2,000 Houstonians. The following year, the parade doubled in size and the crowd swelled to tens of thousands. A year later, caravans of art cars began traveling thousands of miles to be in the annual parade, which attracts over 250 vehicles from 23 states, plus Canada and Mexico. Over 250,000 spectators line Allen Parkway to witness creative interpretations of every imaginable sort of vehicle, from cars and trucks to lawnmowers, go-carts, unicycles, and mobile sculptures.

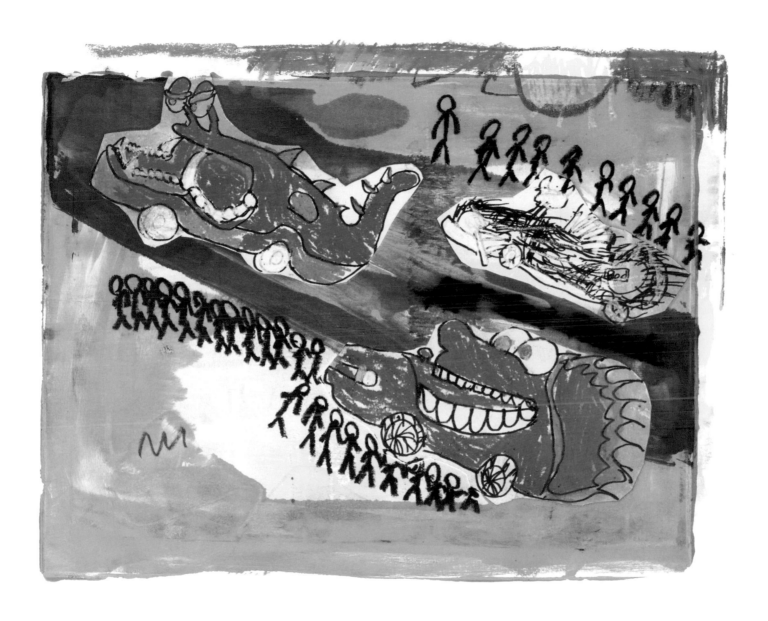

Monoprint with color pencil, markers, and pastel
by Joel Montealvo
Third Grade, Love Elementary School

The Art Car Parade

PHOTOGRAPHS BY FRANCISCO CÁZARES
Fourth Grade, Love Elementary School

Art Car Interior (above)

Honk If Anything Falls Off (right)

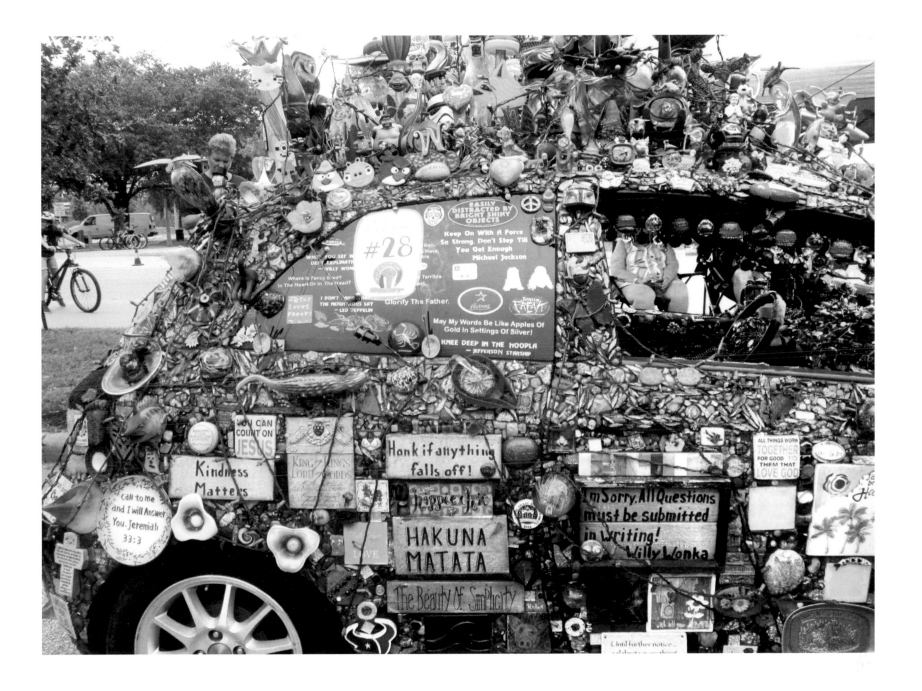

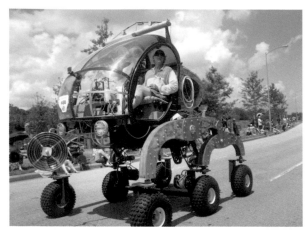
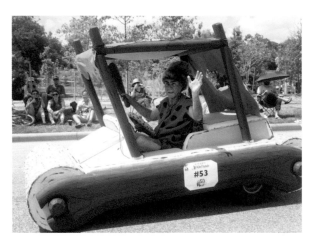
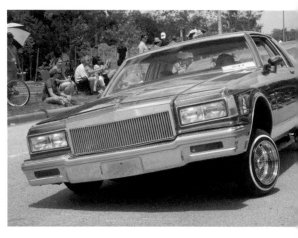
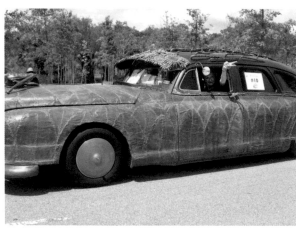
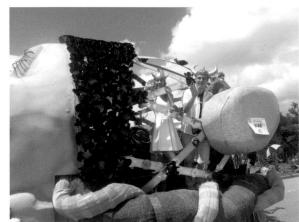
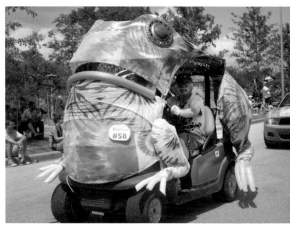
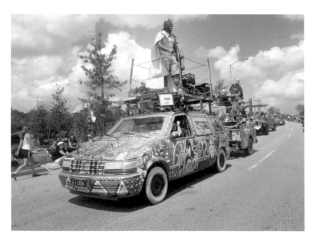
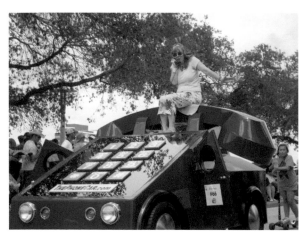
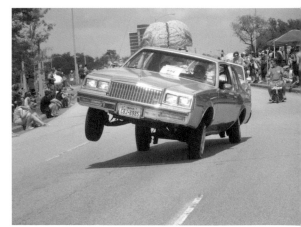

PHOTOGRAPHS BY DYLAN CASSILLO-BROWN *(all above)*
Fourth Grade, Love Elementary School

The Art Car Parade

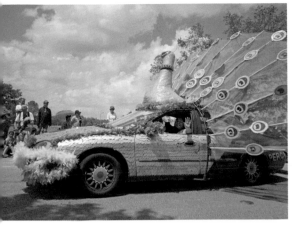 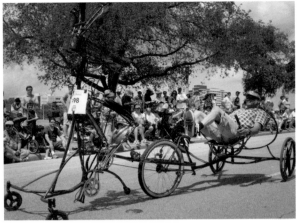

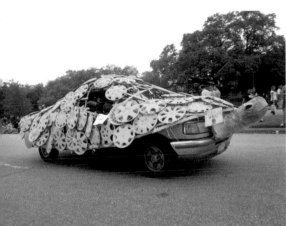 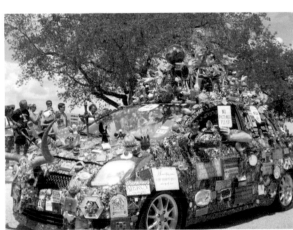 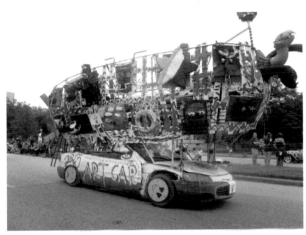

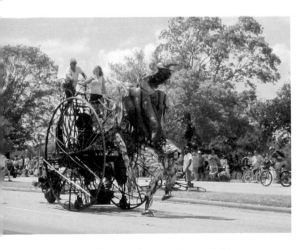 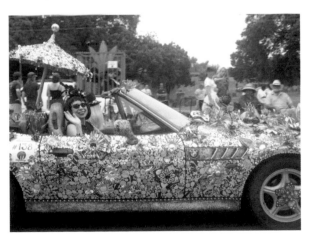 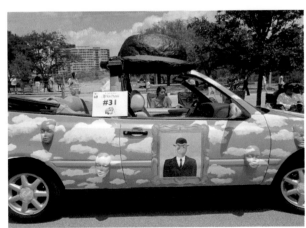

PHOTOGRAPH BY TRISTYN BONSEN *(upper left)*
Third Grade, Love Elementary School

PHOTOGRAPH BY LEXI BALDWIN *(middle row left)*
Fourth Grade, Love Elementary School

PHOTOGRAPH BY KELLY RIVERA *(lower left)*
Sixth Grade, Hamilton Middle School

PHOTOGRAPH BY TRISTYN BONSEN *(upper middle)*
Third Grade, Love Elementary School

PHOTOGRAPH BY TRISTYN BONSEN *(middle row middle)*
Third Grade, Kipp Zenith Academy

PHOTOGRAPH BY LEXI BALDWIN *(lower middle)*
Fourth Grade, Love Elementary School

PHOTOGRAPH BY MAURICIO RIVERA *(top right)*
Third Grade, Love Elementary School

PHOTOGRAPH BY LEXI BALDWIN *(middle row right)*
Fourth Grade, Love Elementary School

PHOTOGRAPH BY ZACHARIAH WROBEL *(lower right)*
Third Grade, Love Elementary School

The Orange Show is a unique, monumental work of handmade architecture, built by the late Jeff McKissack, a Houstonian. McKissack created the Orange Show in honor of his favorite fruit. Working in isolation from 1956 until his death in 1980, McKissack used common building materials and found objects—bricks, tiles, fencing, farm implements—to transform an East End lot into an architectural maze of walkways, balconies, arenas, and exhibits decorated with mosaics and brightly painted iron figures.

The 3,000 square foot, outdoor environment was constructed of concrete, brick, steel, and found objects including gears, tiles, wagon wheels, mannequins, tractor seats and statuettes. Each piece of the Orange Show monument was hand-painted and placed by McKissack.

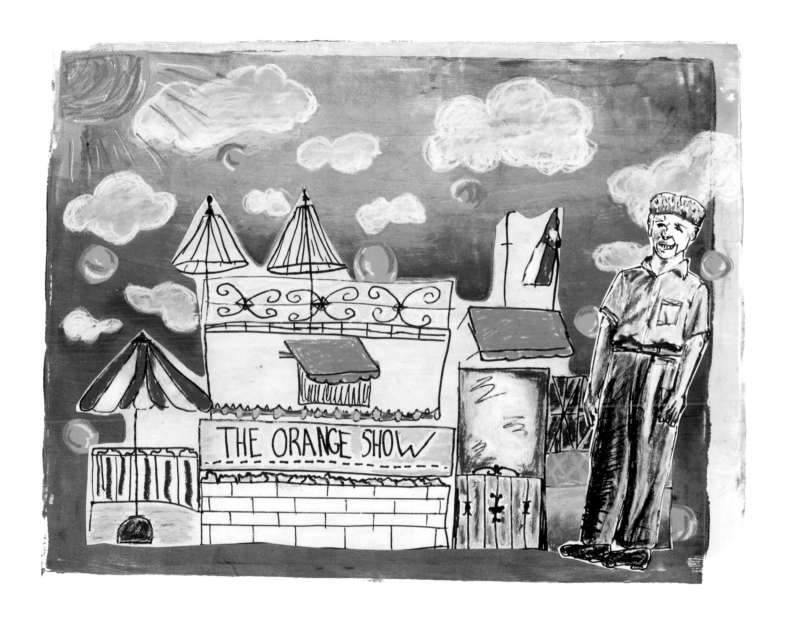

Monoprint with color pencil, markers, and pastel
by Mary Rose Rawson
Fourth Grade, Mark Twain Elementary School

Jeff McKissack and His Orange Show

PHOTOGRAPH BY DARIO AVILÁ
Fifth Grade, Love Elementary School

The Orange Show

PHOTOGRAPH BY THIRAPHAT (OAT) PHENPHICHAI
Fourth Grade, Love Elementary School

The Orange Show (upper left)

PHOTOGRAPH BY KELLY RIVERA
Seventh Grade, Hamilton Middle School

The Orange Show (lower left)

PHOTOGRAPH BY LEXI BALDWIN
Fourth Grade, Love Elementary

The Orange Show (upper right)

PHOTOGRAPH BY ESTEPHANIA ESPINOZA
Fifth Grade, Love Elementary School

The Orange Show (lower right)

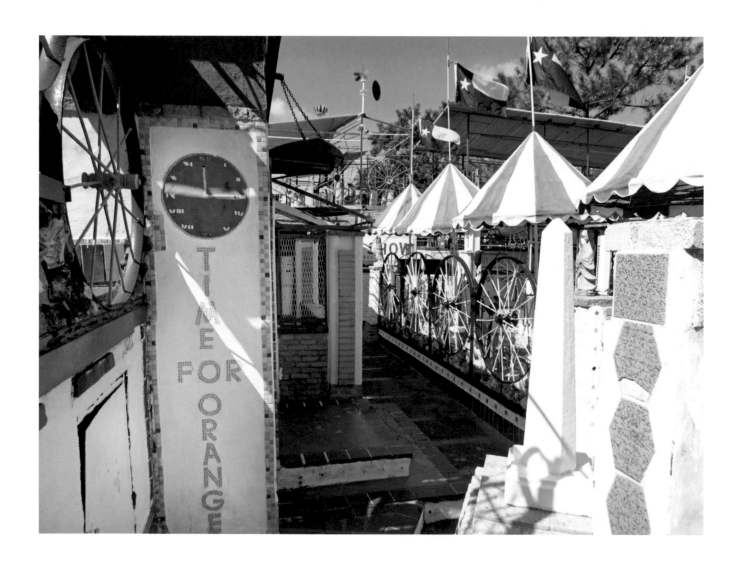

PHOTOGRAPH BY DOMINICK REYES
First Grade, Love Elementary School

The Orange Show (above)

PHOTOGRAPH BY DARIO AVILÁ
Fifth Grade, Love Elementary School

The Orange Show (right)

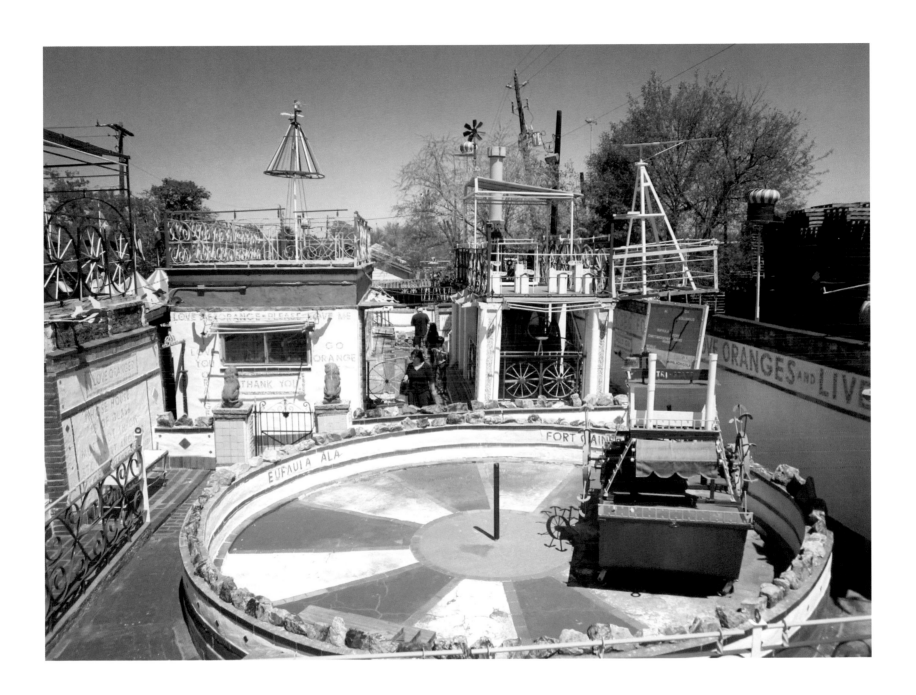

Houston is home to six professional major league sports teams: the Houston Astros (baseball), Houston Texans (football), Houston Rockets (basketball), Houston Dynamo (soccer), Houston Dash (women's soccer), and Scrap Yard Dawgs (fast pitch softball).

All but forgotten today, the city's first professional sports team was the Houston Buffaloes. Named for Buffalo Bayou, the "Buffs" were organized in 1887 and played in the city until 1961, when the team was purchased and renamed by the owners of the new Colt 45s. Renamed again in 1965, they began playing as the Astros. Their home stadium—the Houston Astrodome, often described as "The Eighth Wonder of the World"—was the first fully enclosed, domed sports arena. The Astrodome kept Houston in the sports and entertainment spotlight for more than three decades, asone of the most prestigious venues in the world for sporting events, concerts, political conventions, religious revivals, and thrill shows.

In 2000, the Astros moved to Minute Maid Park, located on the northeast side of Downtown Houston. Built on the grounds of the city's old Union Station, the new stadium features a fully retractable roof and a locomotive that whistles across the outfield after Astros' home runs.

Photograph by Alejandro Santillán
Third Grade, Love Elementary School

Photographing Baseball in Minute Maid Park

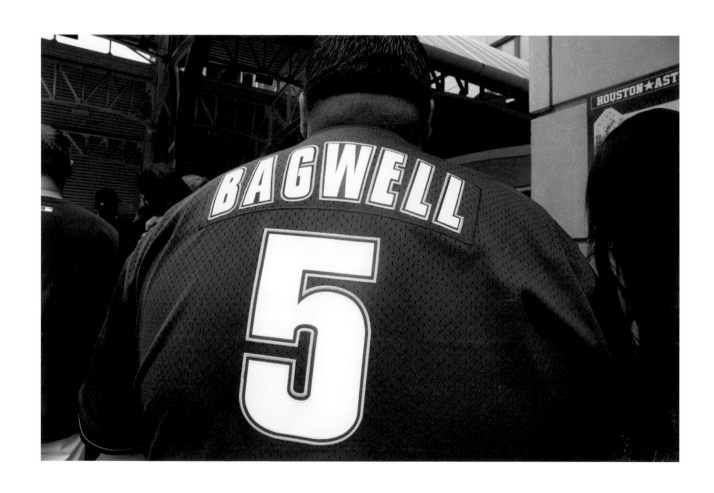

PHOTOGRAPH BY ABIGAIL OYERVIDEZ
Fourth Grade, Wilson Montessori School

Bagwell Comes to the Game (above)

PHOTOGRAPH BY ALEJANDRO SANTILLÁN
Third Grade, Love Elementary School

Baseball in Minute Maid Park (right)

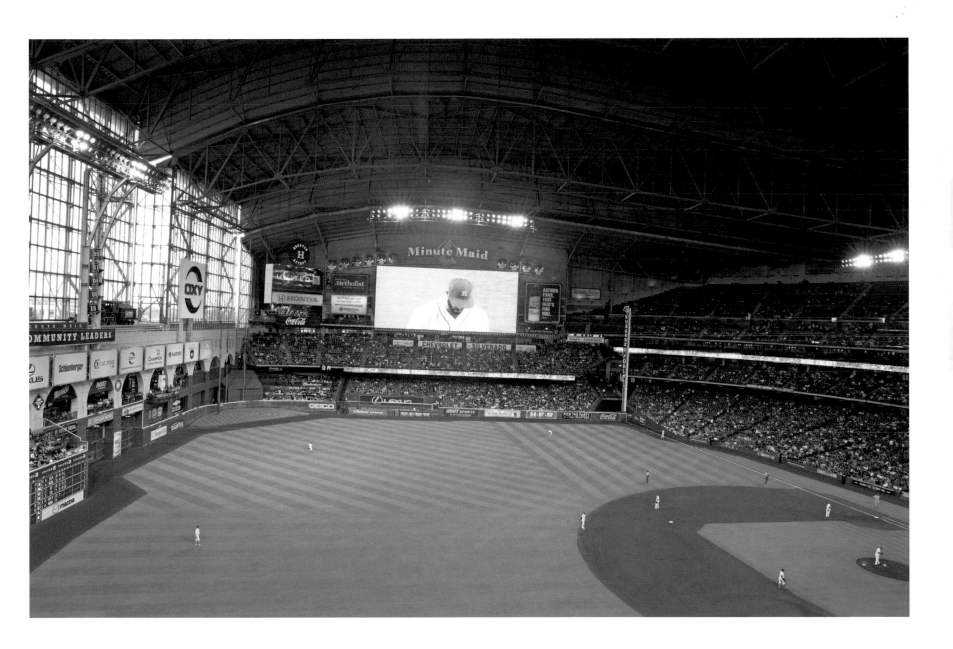

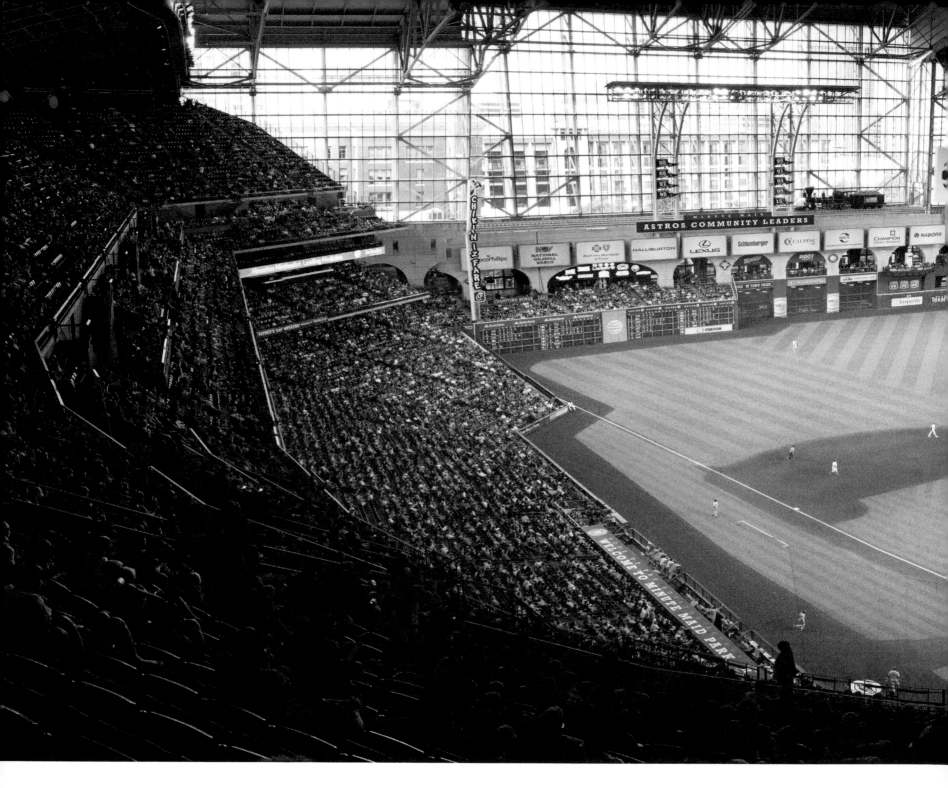

PHOTOGRAPHS BY ALEJANDRO SANTILLÁN
Third Grade, Love Elementary School

Astros Baseball in Minute Maid Park

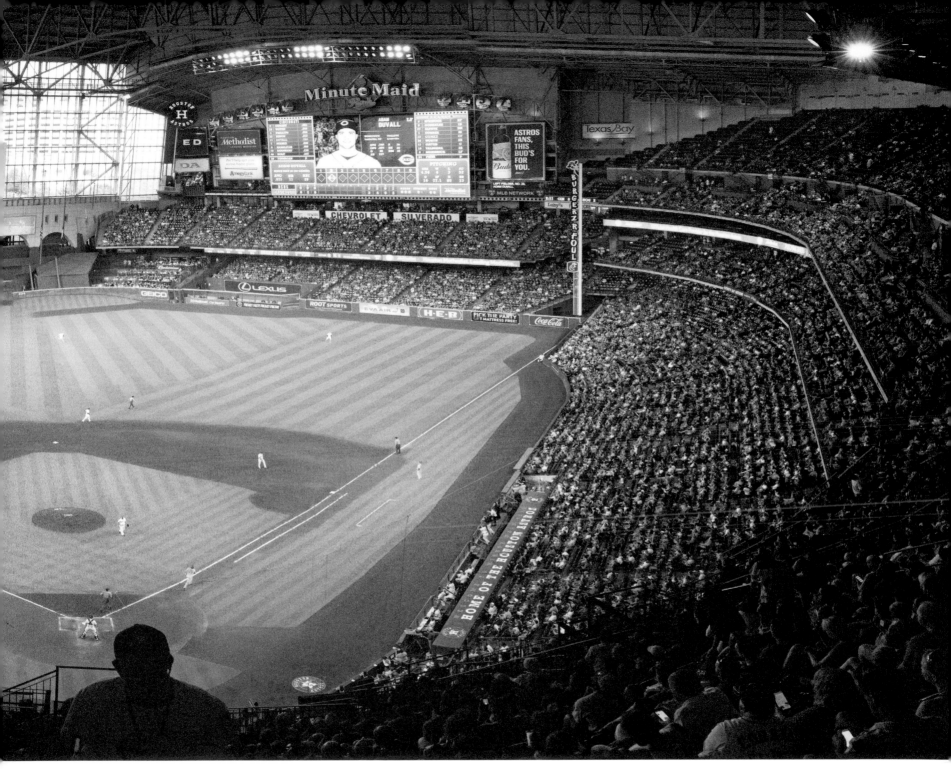

PHOTOGRAPHS BY FRANCISCO CÁZARES
Fifth Grade, Love Elementary School

Houston Texans Football

PHOTOGRAPHS BY FRANCISCO CÁZARES
Fifth Grade, Love Elementary School

Houston Texans Football

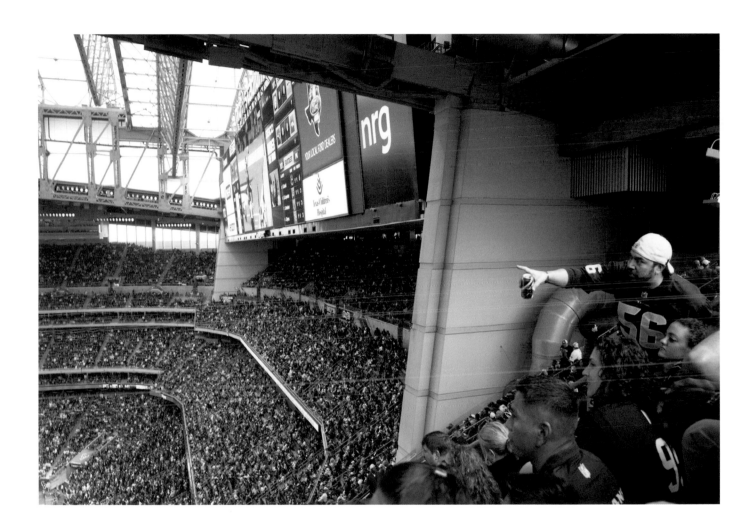

According to city records, fewer than 30 Chinese were living in Houston in 1930. By 1950, the number had grown to 1,000. According to the latest census, 280,341 Asian-origin residents live in the city.

Chinese New Year, also known as Lunar New Year or the Spring Festival, is the most important of the traditional Chinese holidays. Houston's Lunar New Year Festival has grown to be the largest Asian celebration in the state of Texas, a week-long extravaganza featuring authentic Lion and Dragon dancers performing amid exploding fireworks.

PHOTOGRAPH BY EDGAR DE JESÚS
Fourth Grade, Love Elementary School

Dragon Dancer, Lunar New Year Celebration

PHOTOGRAPHS BY FRANCISCO CÁZARES
Fifth Grade, Love Elementary School

Dragon Dancers, Lunar New Year Celebration

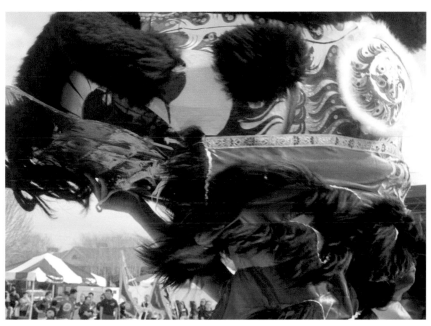

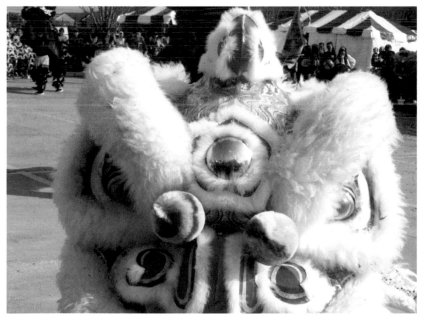

PHOTOGRAPH BY ZACHARIAH WROBEL
Third Grade, Love Elementary School

Cracked Gravestone, Glenview Cemetery (above)

STELLA CASSILLO-BROWN AND TRISTYN BONSEN PHOTOGRAPHING AT GLENVIEW CEMETERY *(right)*

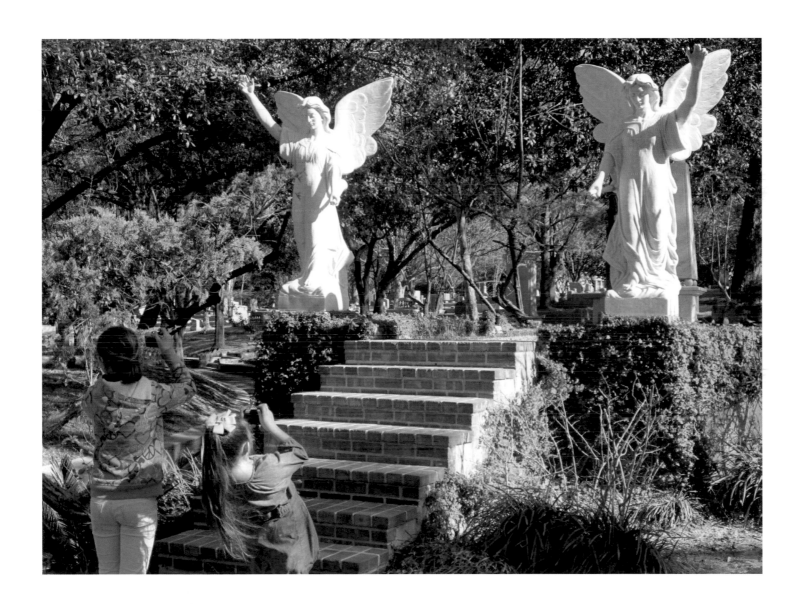

PHOTOGRAPH BY ZACHARIAH WROBEL
Third Grade, Love Elementary School

Child's Gravestone, Glenview Cemetery (above)

PHOTOGRAPH BY TRISTYN BONSEN
Third Grade, Love Elementary School

Gravestone, Glenview Cemetery (right)

REILLEY JONES WITH A FINISHED MONOPRINT

Part VII: Monoprints

The students who created artworks for this project worked exclusively in a process known as monoprinting, a particular form of printmaking in which only one impression is made from a painted plate. The beauty of this process, particularly for young artists, lies in the spontaneity it encourages and in its ability to combine printmaking with painting, collage, and drawing.

Choosing from a great variety of color inks, each student begins a piece by applying inks onto a plywood plate, which are then printed onto a sheet of fine paper by means of an etching press. The next steps then involve some combintation of drawing, painting, or collaging onto the printed color image.

For this particular project, participating students were urged to create images relating to the city of Houston, with particular emphasis on its history. As an aid to their imagination, they were provided with archival photographs of the city, including its natural landscape, industries that shaped its history, and individuals who played a major role in its growth and development.

MONOPRINT WITH COLOR PENCIL, MARKERS, AND PASTEL
BY ALONDRA REYES
Third Grade, Love Elementary School

Houston and Its Natural Creatures

MONOPRINT WITH COLOR PENCIL AND PASTEL
BY REBECCA WOLFARTH
Fourth Grade, Mark Twain Elementary School

The First Bridge over Buffalo Bayou

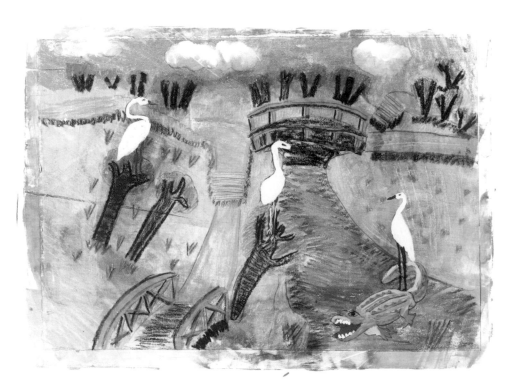

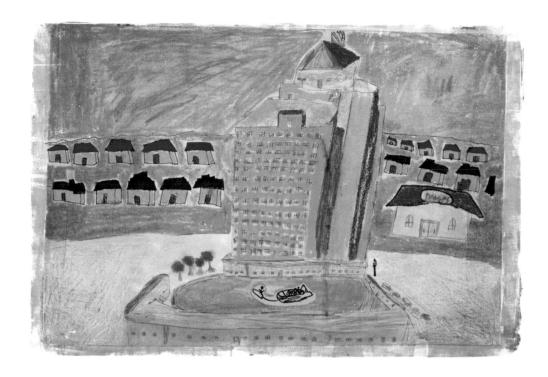

MONOPRINT WITH COLOR PENCIL, MARKERS, AND PASTEL
BY STARLA SÁNCHEZ
Fourth Grade, Mark Twain Elementary School

The Shamrock Hotel

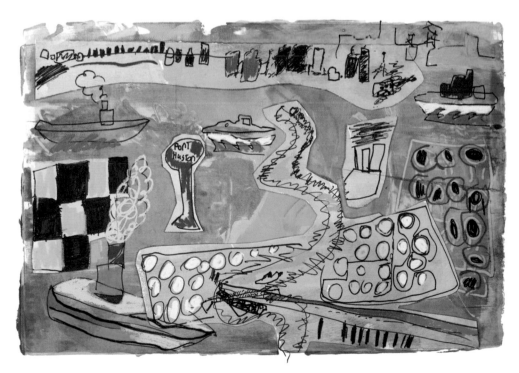

MONOPRINT WITH COLOR PENCIL, MARKERS, COLLAGE, AND PASTEL
BY REILLEY JONES
Fifth Grade, Wilson Montessori School

The Houston Ship Channel

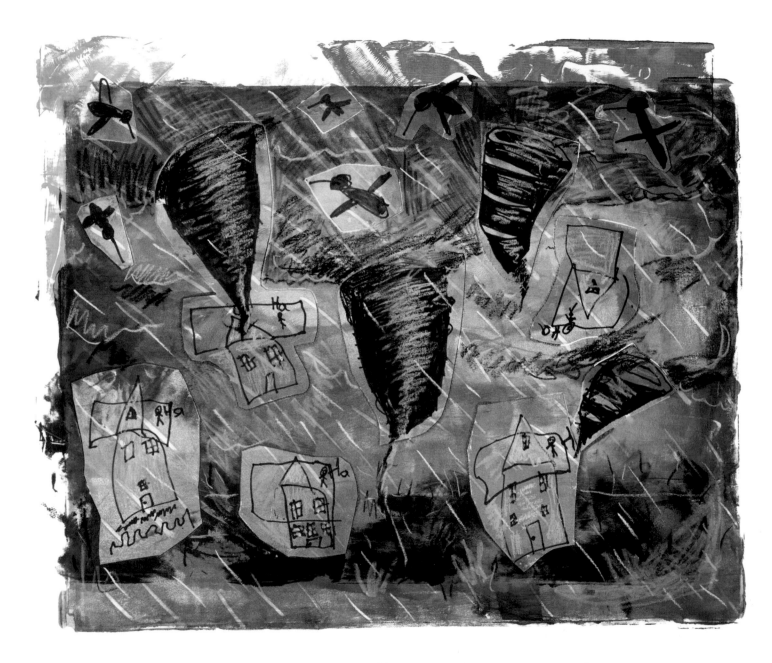

MONOPRINT WITH COLOR PENCIL, MARKERS, COLLAGE AND PASTEL
BY DOMINICK REYES
First Grade, Love Elementary School

Hurricane in Houston

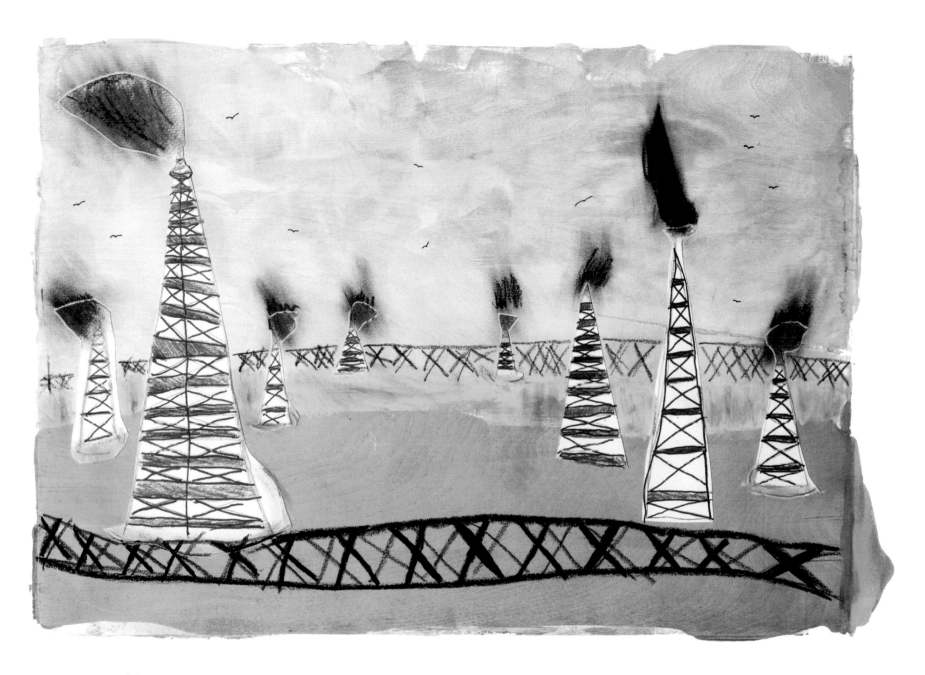

MONOPRINT WITH COLOR PENCIL, MARKERS, AND PASTEL
BY STARLA SÁNCHEZ
Fourth Grade, Mark Twain Elementary School

Oil Fields of Houston

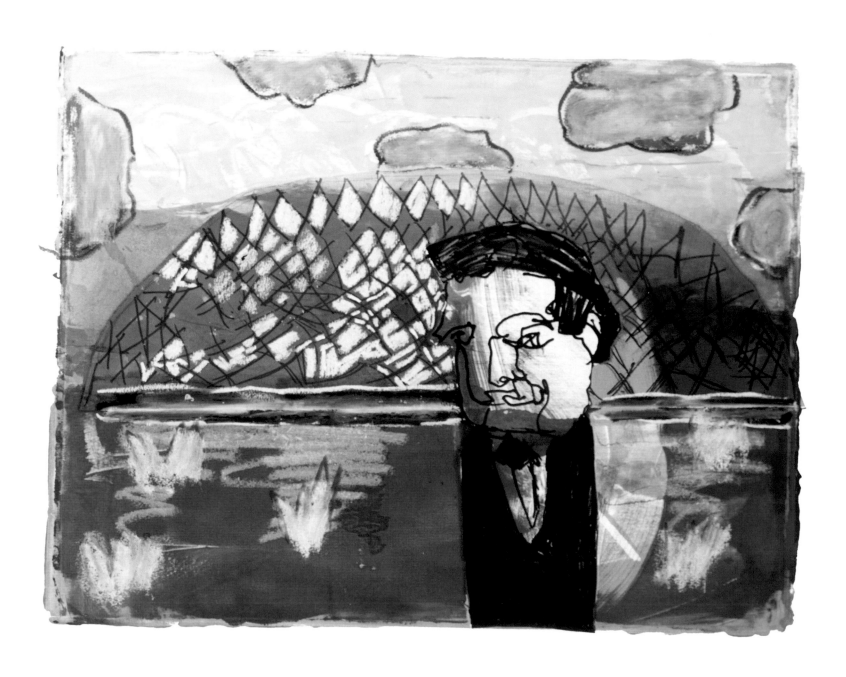

MONOPRINT WITH COLOR PENCIL, MARKERS, AND PASTEL
BY ELIAS BLAIR
Fourth Grade, Wilson Elementary School

Judge Roy Hofheinz and His Astrodome

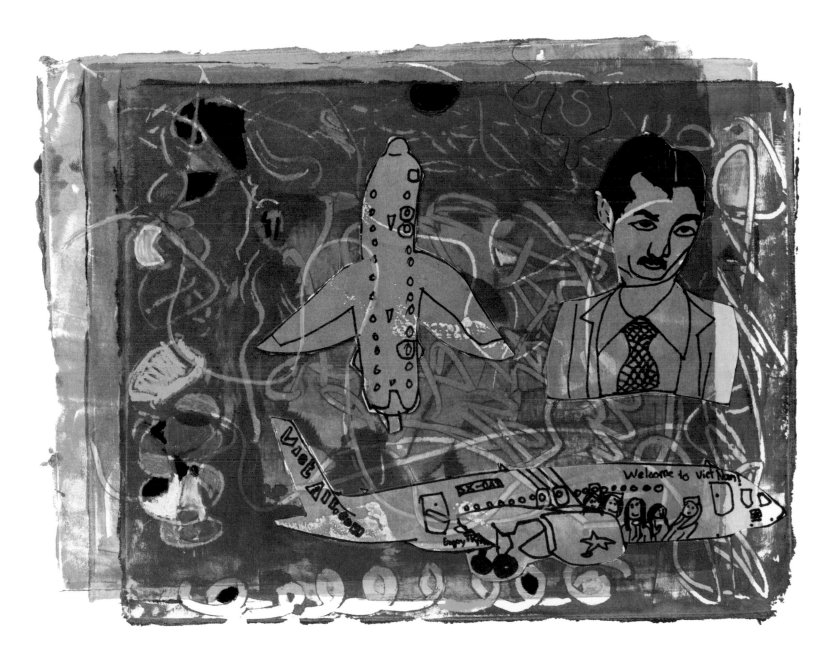

Monoprint with color pencil, markers, and pastel
by Gabriela Rodríguez
Third Grade, Treasure Forest Elementary School

Howard Hughes, The Aviator

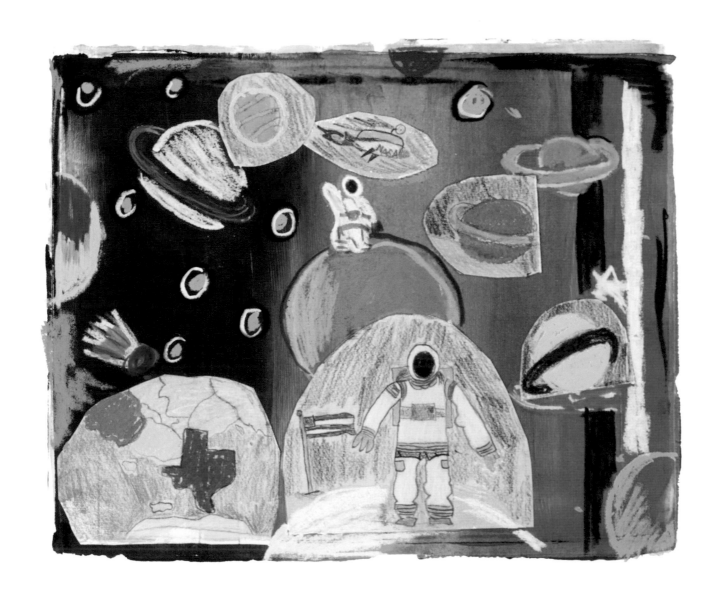

Monoprint with color pencil, markers, and pastel
by Starla Sánchez
Fourth Grade, Mark Twain Elementary School

NASA and Men on the Moon

Monoprint with color pencil, markers, and pastel
by Alek Blair
Fourth Grade, Wilson Montessori School

NASA Rocket to the Moon

Monoprint with color pencil, markers, and pastel
by Dominick Reyes
First Grade, Love Elementary School

Men in Outer Space

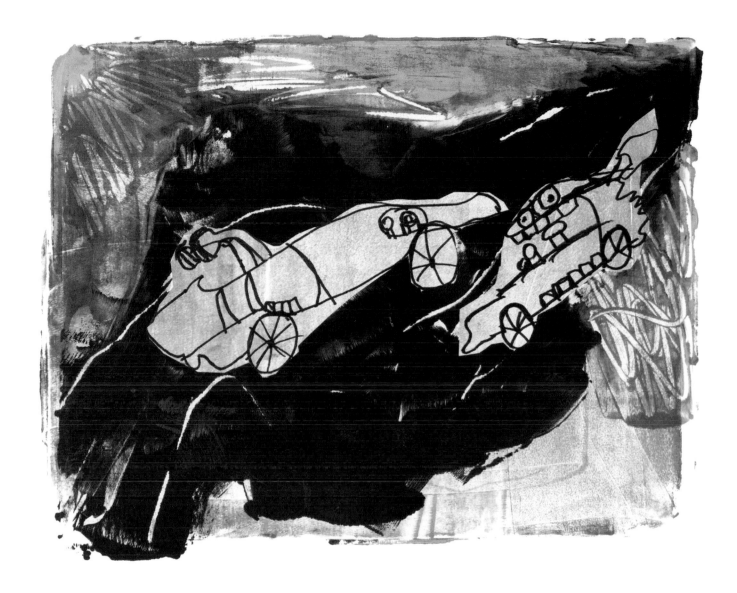

Monoprint with color pencil, markers, collage and pastel
by Angel Corpus
Third Grade, Love Elementary School

The Art Car Parade (top left)

Monoprint with color pencil, markers, collage and pastel
by Heinrich Duarte
Third Grade, Love Elementary School

The Art Car Parade (lower left)

Monoprint with color pencil, markers, collage and pastel
by Elias Blair
Fourth Grade, Wilson Montessori School

The Art Car Parade (above)

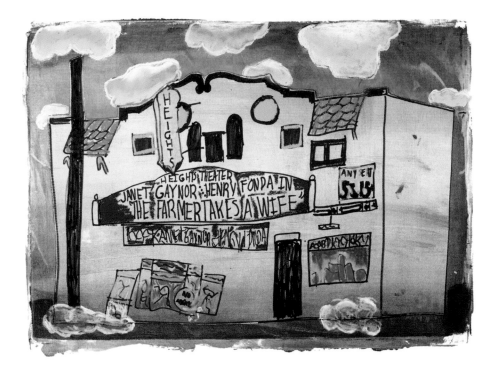

MONOPRINT WITH MARKERS, COLOR PENCIL, AND PASTEL
BY MARY ROSE RAWSON
Fourth Grade, Mark Twain Elementary School

The Heights Theater

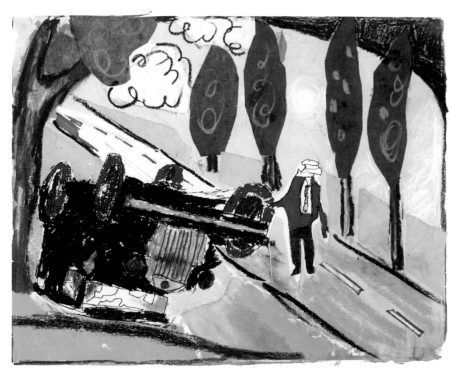

MONOPRINT WITH COLOR PENCIL, MARKERS, AND PASTEL
BY ALEJANDRO SANTILLÁN
Third Grade, Love Elementary School

The First Car Wreck in Houston

272

Monoprint with color pencil, collage, and pastel
by Rhiannon Wolfarth
Fourth Grade, Wilson Montessori School

Houston Rodeo in the Astrodome

Monoprint with color pencil, markers, and pastel
by Joel Montealvo
Third Grade, Love Elementary School

Dr. Denton Cooley

MONOPRINT WITH COLOR PENCIL, MARKERS, AND PASTEL
BY SCOUT SUSTALA
Seventh Grade, Pershing Middle School

The Houston Rockets

274

Dominick Reyes with His Finished Monoprint

Monoprint with color pencil, markers, and pastel
by Alondra Reyes
Third Grade, Love Elementary School

Magnolia Blossoms

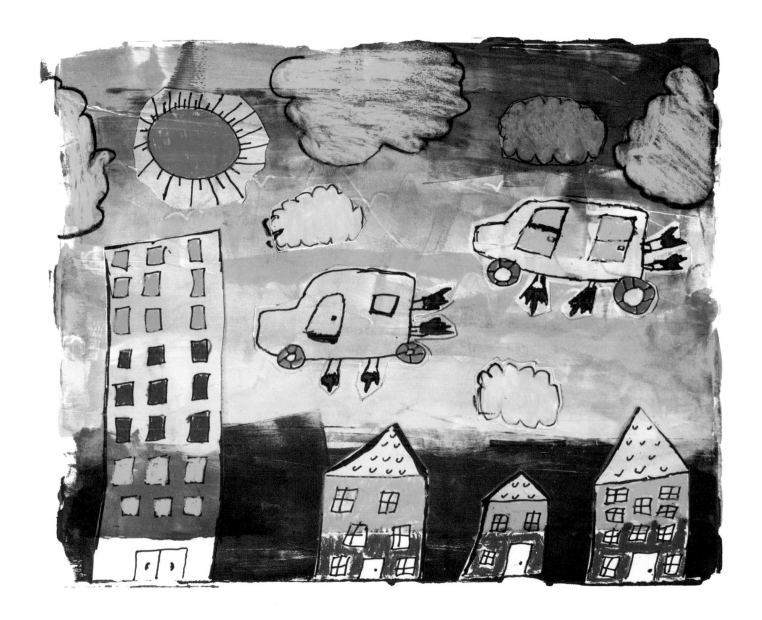

Monoprint with color pencil, markers, Collage, and pastel
by Reilley Jones
Fifth Grade, Wilson Montessori School

Houston in the Future

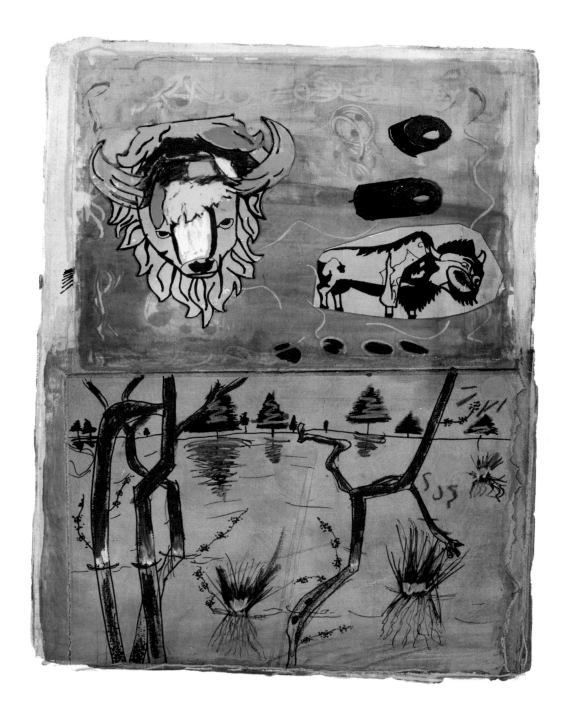

MONOPRINT WITH COLOR PENCIL, MARKERS, AND PASTEL
BY GABRIELA RODRÍGUEZ
Third Grade, Treasure Forest Elementary School

Legend of the White Buffalo

PART VIII: THE LEGEND OF THE WHITE BUFFALO

An enduring legend, familiar to many Houstonians, bespeaks of the time—long before the city existed—when the waters of the bayou were clear, the prairies extended as far as the eye could see, and great herds of buffalo roamed the area.

The story tells of a snow-white buffalo that grazed along the banks of the bayou and drank from its waters. The Indians who hunted in the area worshipped the white buffalo, regarding him as an earthly embodiment of their Great Spirit. The Indians killed other buffalo for food and hides, but they left the sacred white one untouched.

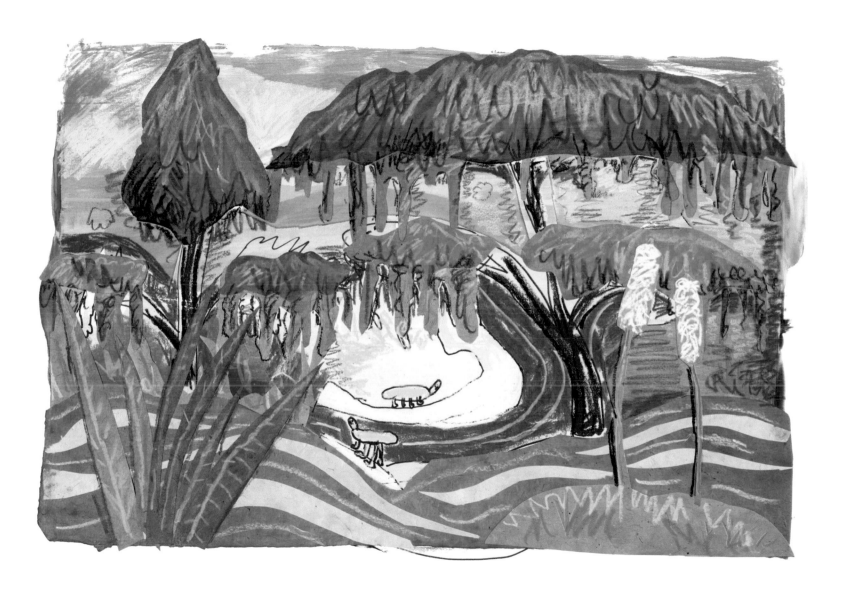

Monoprint with color pencil, markers, and pastel
by Emily Whittemore
Teaching Assistant

Buffalo Bayou

One day, a white hunter appeared and killed the white buffalo for its beautiful hide. The Indians were struck with grief and fear. They prayed to the Great Spirit, pleading their innocence and begging not to be punished. For many days and nights, they grieved the loss of the white buffalo and lived in fear of the Great Spirit's anger and revenge.

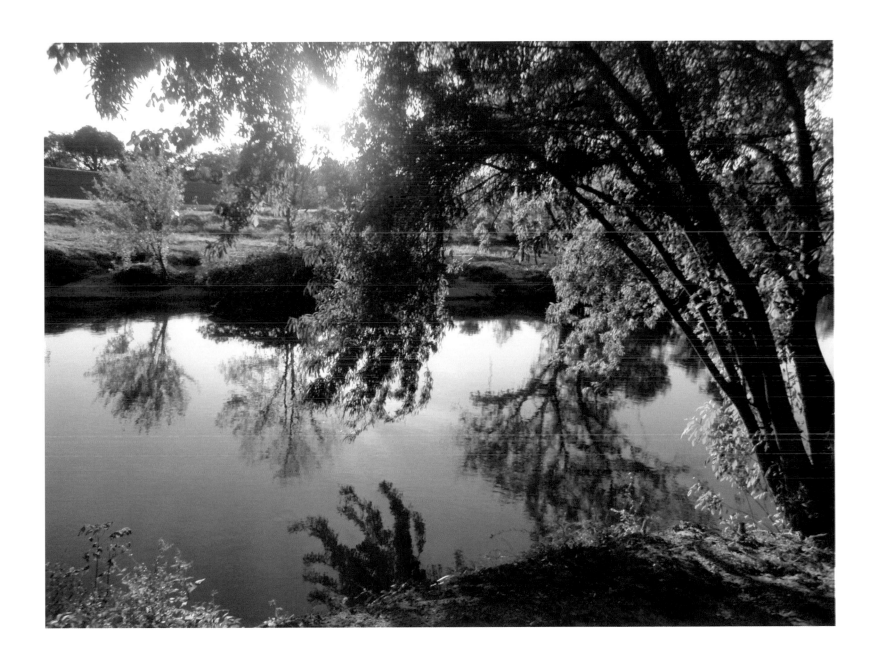

PHOTOGRAPHS BY EDGAR DE JESÚS
Fourth Grade, Love Elementary School

Buffalo Bayou Park

Then, magically, a great tree with magnificent white flowers appeared on the banks of the bayou where the white buffalo had grazed. The Indians believed that the tree was a message of forgiveness from the Great Spirit and that it carried the soul of the sacred buffalo in its velvet white blossoms.

The Indians named both the bayou and the tree for the buffalo. Today, we still call the stream Buffalo Bayou, but we know the Buffalo Tree as the magnolia.
Magnolia trees still grace the city, particularly along the banks of the bayous. In the spring, when their delicate white blossoms open, they remind us how fragile the natural world is, how easily it can be abused or neglected.

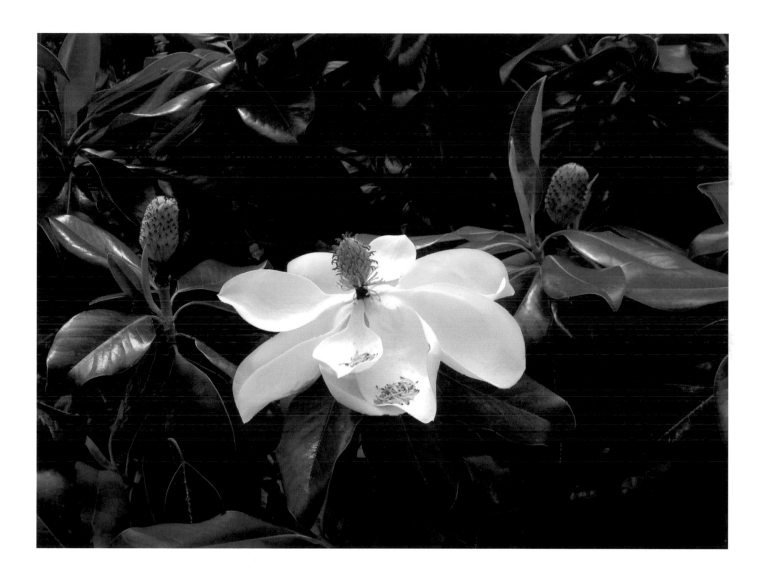

Photographs by Abigail Oyervidez
Fourth Grade, Wilson Montessori School

Magnolia Blossom

Remants of the natural beauty of the place can still be found, even within the heart of the city, and even as its steady growth continues. A walk along the bayou in the heart of downtown can offer surprising glimpses of nature thriving in the very shadows of the freeways. Careful observations can reveal an elegant natural arrangement of climbing vines on a stop sign or a telephone pole. The most humble vacant lot can be covered in spring-time with a carpet of rich, verdant grasses.

The children of this generation are the citizens and leaders of the future city. The specific images they have seen and described in these photo-graphs will change in the years ahead. As the city approaches its 200th anniversary, there are clear signs that city government, business interests, and the population at large are beginning to pay serious attention to the rich and diverse natural environment in which Houston is situated. Civic organizations primarily concerned with the natural landscape of the city, such as Houston Wilderness and Bayou Greenways 2020, are helping to transform the Houston region. They are expanding our understanding of the remarkable ecosystems of the area, how delicate these systems are, how critical it is that we act to protect them, and how they can make life within the city even more rewarding for ourselves and for future genera-tions of children.

PHOTOGRAPH BY ANGEL MENA
Fifth Grade, Love Elementary School

Bingham Street, First Ward

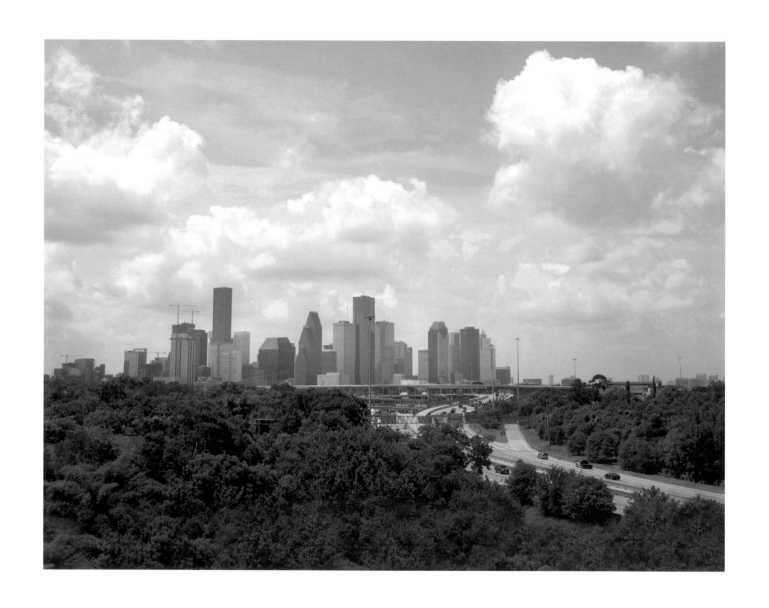

PHOTOGRAPH BY REBECCA WOLFARTH
Fourth Grade, Wilson Montessori School

Houston Skyline and the North Freeway

AFTERWORD

What a remarkable collection of Houston images! With all the innocence and spontaneity that befit their years, these young artists, aided by their intrepid guides, have captured beautifully the diversity and dynamism of our city. They have helped us to see through new eyes Houston's deep rootedness in its natural ecology, its rich consumer and culinary culture, its extraordinary museums, arts and sports venues, the remarkable array of its recreational offerings, and the unexpected beauty in the streets and freeways of this sprawling car-dependent city.

Houston has been working hard these days to reinvent itself in an effort to attract and retain the most innovative companies and talented individuals, the "knowledge workers" who will fuel the engines of today's economy and who are freer today than ever before to choose where they would like to live. The images in this volume remind us of the progress we have made in this connection and of the many additional opportunities we have to turn Houston into an even more aesthetically and environmentally attractive urban destination.

Most of the low-skill well-paid blue-collar jobs (as in Houston's oil-field manufacturing industries) have now disappeared. The new economy is marked by growing inequalities predicated above all else on access to quality education and technical skills. The images of their home lives that these young photographers depict give some indication of the poverty many are experiencing, but they also reflect the triumph of the human spirit, in the unmistakable optimism and the love of family that they portray.

At the same time, Houston is at the forefront of the epic demographic transition that is taking place in the composition of the U.S. population, as an earlier generation, predominantly Anglo and now aging, is being replaced by a new generation of Americans, who are a mix of all the ethnicities and religions of the world. The 132 student photographers and printmakers who participated in this collection embody that new diversity: 43 percent are Hispanic, 30 percent Anglo, 16 percent African-American, and 11 percent Asian.

These will be the citizens and leaders of Houston as the twenty-first century unfolds. If they are at all representative of their generation, the extraordinary work that these young people have produced makes it clear that the city's future is in good hands.

Stephen L. Klineberg

Professor of Sociology and Founding Director
The Kinder Institute for Urban Research, Rice University

Index to Photographs and Monoprints

Note: All unattributed photographs—pictures of the students photographing or at work in the printmaking studio—were taken by project staff members or volunteers.

Index to Subjects

Anna Bremauntz, Georgie Rawson, Estephania Espinoza, Alejandro Santillán, and Harper Gilbert *(left to right)* at Notsuoh

Acknowledgments

The project that led to the publication of this book began in the spring of 2011, when the late Sandra Bernhard, then director of Houston Grand Opera's community outreach (HGOco), invited the Pozos Art Project to join their "Home + Place" program in the public schools of Houston. We are indebted to HGOco and to Sandra, whose imagination and inspiring leadership initiated this project.

Professor Linda McNeil and Karen Capo of Rice University's Center for Education introduced us to principals and teachers in Houston public schools and provided essential advice in the initial stages of the project.

We are grateful to all of the principals and teachers from the participating schools, without whose cooperation and enthusiastic support, this project would have been impossible. In particular, Elizabeth Jordan, art instructor at Love Elementary School, gave countless hours, provided valuable insights, and brought a wide range of talented children into the project.

Rice University contributed to this project in a number of important ways. Through Rice's Center for Civic Leadership, the Rich Family Endowment Fund granted financial support for the purchase of cameras and supplies; the Doerr Institute for New Leaders at Rice provided major funding for summer workshops; the Humanities Research Council and the Department of Dramatic and Visual Arts at Rice granted funds for the creation of an archive of student work and for the opening exhibition at the Rice Media Center.

This book and the exhibition that accompanies it would not have been possible without the generous financial support of Houston First Corporation and the Houston Arts Alliance.

We thank the Buffalo Bayou Partnership for generously providing boat tours of Buffalo Bayou for our students. We also thank the Houston Astros, Miller Outdoor Theatre, Memorial City Mall, the Museum of Fine Arts, Houston, and Space Center Houston for granting permission and generously providing tours for our students.

We express our deep appreciation to The Honorable Sylvester Turner, Mayor of the City of Houston, for his foreword to the book, and to Houston City Councilman David Robinson for his enthusiastic support of this project.

Finally, we thank Stephen L. Klineberg, Professor of Sociology and Co-Director of the Kinder Institute for Urban Research at Rice University, for his afterword, and for the inspiration and critical help he gave toward the completion of the book.

G. W.

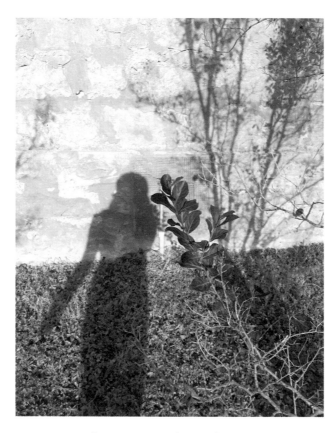

PHOTOGRAPH BY ADALIA GARCÍA
Fifth Grade, Love Elementary School

Self-Portrait

The Pozos Art Project, Inc., is a 501(c)3 non-profit organization
providing workshops in the visual arts to children and young adults
in Houston, Texas and in Mineral de Pozos, Mexico.

Board of Directors
Travis C. Broesche - Houston
Susan M. Edwards - Houston
Janice Freeman - Houston/Pozos
Geoff Winningham - Houston/Pozos
David Winslow - Pozos

The Pozos Art Project, Inc.
2408-A Park Street, Houston, Texas 77019
www.pozosartproject.com